POSTCARD HISTORY SERIES

Manhattan Churches

POSTCARD HISTORY SERIES

Manhattan Churches

Richard Panchyk
Foreword by Timothy Cardinal Dolan, Archbishop of New York

ARCADIA
PUBLISHING

Published by Arcadia Publishing
Charleston, South Carolina

Printed in the United States of America

Library of Congress Control Number: 2016937022

For all general information contact Arcadia Publishing at:
Telephone 843-853-2070
Fax 843-853-0044
E-mail sales@arcadiapublishing.com
For customer service and orders:
Toll-Free 1-888-313-2665

Visit us on the Internet at www.arcadiapublishing.com

In Honor of St. Lucy, Patron Saint of Writers

CONTENTS

FOREWORD

Manhattan's many churches represent the borough's long history of rich diversity and growth. Since the first church was built at the southern tip of the island nearly 400 years ago, hundreds upon hundreds of churches of all denominations have been constructed. Churches are such an integral part of Manhattan's identity that several of our houses of worship are considered must-see stops for visitors from around the world.

This book takes the reader on a visual, historical journey through a sampling of Manhattan's churches, offering a glimpse at the stunning spiritual and architectural beauty this borough has to offer.

—Timothy Cardinal Dolan, Archbishop of New York

ACKNOWLEDGMENTS

Thanks go to the dedicated team at Arcadia for publishing my fourth title in an excellent line of high-quality books, and to my excellent title manager, Henry Clougherty. Thanks also go to my family and friends for their continued inspiration and support.

This book is a pictorial history of Manhattan's churches, but it is by no means a comprehensive representation of every church. The contents of this book are limited by both space and in large part by which churches are featured on postcards. The Manhattan churches most commonly depicted during the early decades of postcard manufacture were the city's most famous then and are still the most famous today: Trinity Church, St. Paul's Chapel, Grace Church, the Cathedral of St. John the Divine, the Little Church Around the Corner, and St. Patrick's Cathedral. Most image dates given are approximate. They may represent the date of the postmark or sometimes the copyright date of the image. In some of the captions, I have noted the postcard publisher. I have also noted the postcard finishing process, space permitting and where that information is available. About 70 percent of the postcards shown in this book were never mailed. The used postcards that are depicted in this book were sent to points both near (New York) and far (places as distant as California, Canada, and France).

Unless otherwise noted, all images are from the author's collection.

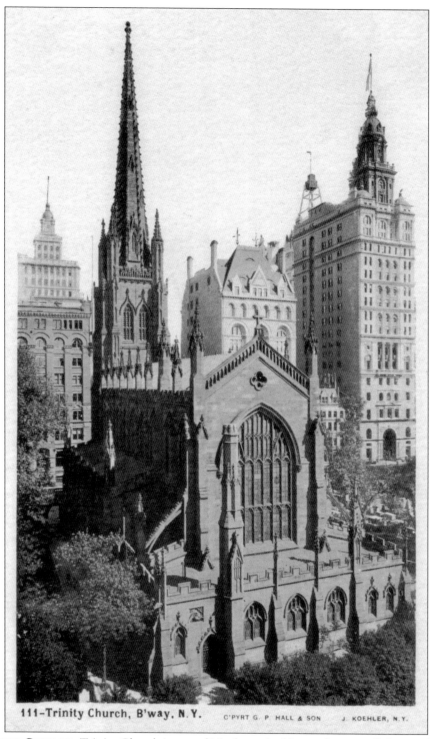

111-Trinity Church, B'way, N.Y. C'PYRT G. P. HALL & SON J. KOEHLER, N.Y.

TRINITY CHURCH. Trinity Church is one of Manhattan's oldest and most well-known houses of worship. Trinity received its royal charter in 1697, and the current building, designed by Richard Upjohn, dates to 1846.

INTRODUCTION

Manhattan's hundreds of churches are lasting reminders of New York City's rich religious and cultural history. In Manhattan, one is never more than a few blocks away from the nearest church. Scattered all across the city's oldest borough, they stand proudly, nestled amidst a constantly changing and modernizing urban landscape. Turning a corner and suddenly encountering a grand old church is like finding a shimmering pearl tucked within an oyster, a gem within what are often drab, nondescript surroundings. Towering steeples that were once the tallest point for many blocks may now be dwarfed by the height of neighboring buildings, but are still wondrous sights nonetheless, providing beautiful contrast between the secular and the divine.

Designed by some of the greatest architects of their time, many of Manhattan's churches are architectural masterpieces, with intricate and awe-inspiring stone facades. Yet stepping inside reveals an even more inspiring sight. What looks so solid and massive from the outside is transformed into a soaring, breathtaking space that shrouds all who enter in a serene, respectful silence. Entering Manhattan's churches instantly transports visitors from the noisy bustle of New York City streets into quiet beauty—a sacred, peaceful space. Upon crossing the threshold into the sanctuary, one goes from the harsh brightness of outside to a gentle and reverent light filtered through the colorful stained-glass windows and emanating from flickering candles and the gently glowing light fixtures. Golden accents on the altar and throughout the church glint in this heavenly illumination like hidden treasures.

Manhattan's churches seem like proud matriarchs, permanent fixtures in the neighborhoods they grace, but I was surprised to discover just how many of them have relocated over the years, moving north to follow their children, parishioners who left for new homes as the city evolved. Churches catered to a diverse array of groups in every corner of the 13-mile-long island—there was even a floating church in the East River especially for sailors who came into port.

Manhattan's churches have seen many illustrious and legendary figures kneeling in their pews. George Washington worshipped at St. Paul's Chapel on Broadway during his presidency. Theodore Roosevelt frequented the Collegiate Church on Forty-Eighth Street. Ulysses Grant attended the Metropolitan Temple Methodist Episcopal Church on Thirteenth Street when he lived in New York after his presidency. Eleanor Roosevelt was confirmed at the Church of the Incarnation on Madison Avenue, and her mother-in-law Sara Delano Roosevelt's funeral was held there; a special ramp was built so Pres. Franklin Roosevelt could attend the services. Billy the Kid was baptized at Old St. Peter's Church on Barclay Street, and playwright Eugene O'Neill was baptized in the Church of the Holy Innocents on Thirty-Seventh Street. Edgar Allan Poe was a parishioner at All Saints' Church on Henry Street. Broadway's stately Grace Church was

the site of the wedding of the legendary Tom Thumb and his bride, Lavinia Warren. St. Patrick's Cathedral has been the scene of funeral masses for countless celebrities, ranging from baseball great Babe Ruth to television host Ed Sullivan to New York senator Robert F. Kennedy.

Although Fifth Avenue's magnificent St. Patrick's Cathedral is among the best-known churches in the country today, and the Archdiocese of New York now includes more than 2.5 million Catholics, Manhattan did not have a single Catholic church for its first 160 years of existence.

Upon its founding in the early 17th century, the city was called New Amsterdam and was filled mainly with Dutch Protestants who belonged to the Dutch Reformed Church, of which the first house of worship was built in 1633. Following the British capture and renaming of the city to New York in 1664, there was a great influx of English Protestants, who built their own churches, including Methodist and Anglican (which was reborn as the Episcopal Church in 1789). Another early presence in 18th-century Manhattan was the Presbyterian Church, popular with Scottish and Irish immigrants. The Catholic population in all of New York State was only 1,500 by the 1780s, and Manhattan's first Catholic church was built in 1785. By 1830, there were only four Catholic churches in the city, and by 1840, there were just 10. It was only with the influx of Irish immigrants during the late 1840s that the Catholic population of the city really began to grow by leaps and bounds. Dozens more Catholic churches were built to accommodate the many thousands of German, Italian, and other Central and Eastern European immigrants who arrived in New York during the mid- to late 19th century.

As Manhattan's population continued to grow and change during the 19th and early 20th centuries, many more churches rose representing a wide variety of denominations, including Baptist, Lutheran, Christian Science, and others. New churches continued to be built all across Manhattan well into the 20th century. One of the city's largest and most impressive churches (featured prominently in this book), Riverside Church was completed in the 1930s. The largest church in the city (and one of the largest in the world, also featured prominently in the book), the Cathedral of St. John the Divine was begun in the 1890s and is still not complete to this day. The fascinating story of Manhattan's churches will continue to be written long into the future.

One

LOWER MANHATTAN

Lower Manhattan is the oldest part of New York City. It was first settled by Dutch traders in 1624. A little village promptly sprang up at the southern tip of Manhattan island, complete with a small fort. Manhattan's first pastor, Jonas Johannis Michaelius, arrived from Holland in 1628, and the first church, a Dutch Reformed church, was built in 1633. When the British took control of the city in 1664, they built their own Anglican churches, but a thriving Dutch population ensured that the Dutch churches continued to thrive as well. Gradually, as new settlers arrived from all over Europe, new denominations were added to the growing list of Manhattan's churches. As the decades passed, development kept moving farther and farther north, with churches constructed as neighborhoods were built and settled.

While that original Dutch church and other early churches are long gone, Lower Manhattan still retains a rich religious heritage, and it is home to some of the oldest, most historic, and most famous churches in the city—treasures such as St. Paul's Chapel (1766), St. Mark's in the Bowery (1799), the old St. Patrick's Cathedral (1815), old St. Peter's Church (1840), John Street Methodist Church (1841), and Trinity Church (1846).

CHURCH OF OUR LADY OF THE ROSARY. Visible at the very tip of Manhattan Island in this c. 1980s postcard, sandwiched between the two black buildings, the two smallest structures are the 1964 Catholic church designed by Shanley & Sturges (left, at 8 State Street) and the James Watson house (right, at 7 State Street and built in 1793). The church was built on the site of what was the home of St. Elizabeth Ann Seton between 1801 and 1803. Seton was the first American-born person to become a saint. The badly deteriorated Seton home was demolished in the 1960s, and the church was erected in its place. The Watson House, also deteriorated, was given a major rehabilitation and is now the shrine for St. Elizabeth Ann Seton. Both addresses used to be home to the Irish Mission for Immigrant Girls, founded during the 1880s. The mission provided assistance to more than 100,000 Irish girls.

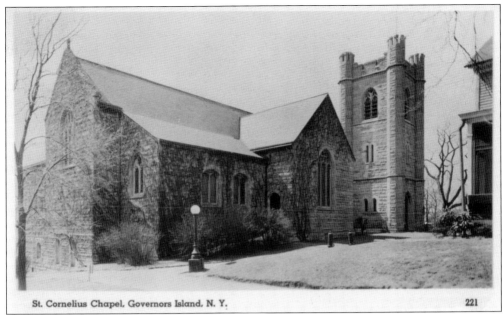

St. Cornelius Chapel, Governors Island, N. Y. 221

ST. CORNELIUS CHAPEL. Governors Island lies just a half mile south of Manhattan in New York Harbor. The first chapel on this longtime military base was built in 1846 with support from Trinity Church. It officially became part of Trinity Parish in 1868. By the turn of the 20th century, the original building was in bad shape. The Gothic-style stone building shown on this c. 1930s–1940s Alfred Mainzer postcard replaced the original wooden structure in 1906. It was designed by Charles C. Haight.

SEAMEN'S CHURCH INSTITUTE. Founded in 1834 by Episcopalians, this organization was created to promote Christianity among merchant mariners and provide a spiritual home for sailors who spent most of their time at sea; it also offered educational and counseling services. In 1844, it erected its first church, which was a floating church that was moored off of Pike Street on the Lower East Side. In 1906, the organization moved to headquarters located in a 13-story building at 25 South Street, which was its home until 1968. Within the building were a chapel, game room, employment bureau, post office, luncheonette and soda fountain, printing shop, reading room, lounge, bank, clothing store, and tailor shop.

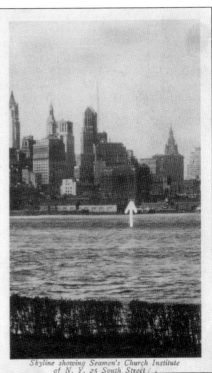

Skyline showing Seamen's Church Institute of N. Y. 25 South Street

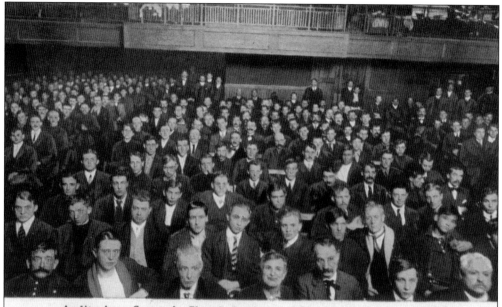

Auditorium, Seamen's Church Institute of New York, 25 South Street

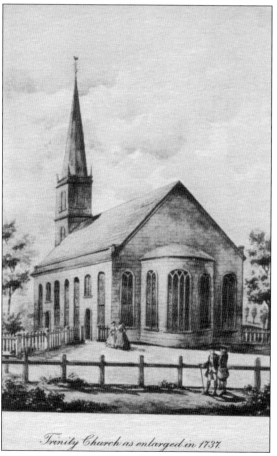

Trinity Church as enlarged in 1737.

SEAMEN'S CHURCH INSTITUTE AUDITORIUM. This postcard shows the packed auditorium of the building at 25 South Street around 1910. In June 1918, German submarines torpedoed nine ships off the coast of the United States. Following the disaster, the Seamen's Church Institute converted the auditorium into a dormitory to offer lodging to the survivors of those torpedoed ships.

TRINITY CHURCH, FIRST BUILDING. The original Trinity Church was founded under a charter granted by King William III in 1697. It was built at the end of the 17th century and opened for services on March 13, 1698. It was enlarged in 1737, and at the time, it was described as "one of the largest and most splendid churches in the country." It was 146 feet long and 72 feet wide, with a spire of 180 feet. The building stood until it was destroyed in the great fire of 1776, which burned one-third of the city.

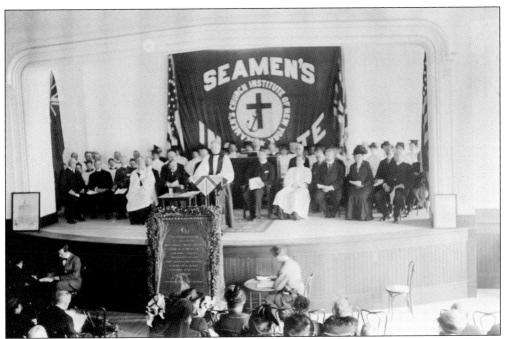

SEAMEN'S CHURCH INSTITUTE LIGHTHOUSE TOWER. In 1913, a special memorial service was held at the Seamen's Church Institute for the victims of the *Titanic* disaster. In honor of the *Titanic*, Rev. David Greer, Bishop of New York, gave a sermon dedicating a lighthouse tower for the roof of the building: "As its light by night shall guide pilgrims and seafaring men from every clime into this port, so may they follow Him who is the Light of Life across the waves of this troublesome world to everlasting life." The lighthouse had a green light that was visible for 12 miles. The photograph above shows the service, and the lighthouse tower is visible on the right corner of the roof on the postcard below. The plaque that was placed on the tower is visible in the photograph of the service. The tower was removed and given to the South Street Seaport Museum in 1976. It is located at Pearl and Fulton Streets. (Above, courtesy of the Library of Congress.)

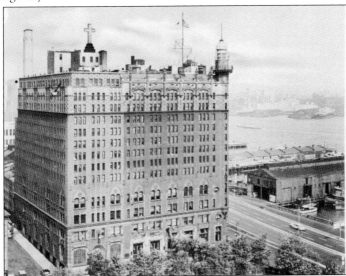

SEAMEN'S CHURCH INSTITUTE OF NEW YORK

On the lower tip of Manhattan, the hub of New York's busy harbor, stands the world's largest shore home for active merchant seamen.

A tribute to the service the Institute has performed during the past century is its growth from a floating chapel in 1844 to its present building at 25 South Street, home to seafarers of all nations and races.

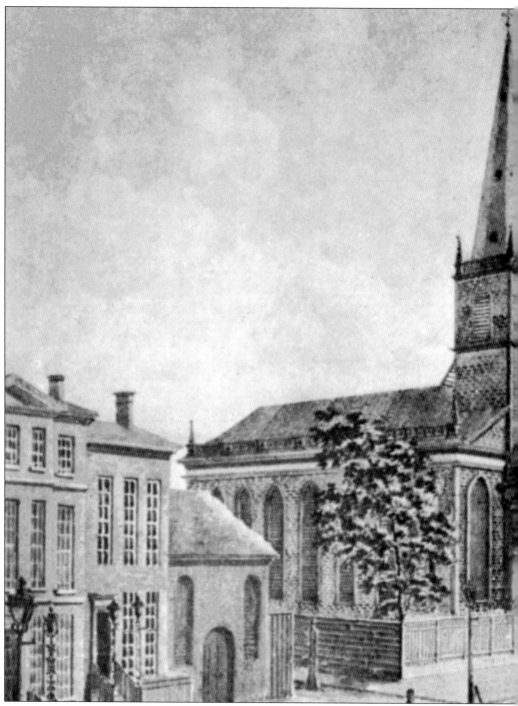

TRINITY CHURCH, SECOND BUILDING. Nothing further was done to replace the destroyed Trinity Church until after the Revolution had ended. The state legislature ratified the Trinity Church Charter in 1784, and the second Trinity church, begun in 1788 and completed in 1790, was consecrated by Bishop Samuel Provoost in the presence of Pres. George Washington and

other dignitaries. Because Trinity was incomplete at the time of Washington's inauguration as president in 1789, he attended a service at nearby St. Paul's Chapel instead. The second Trinity Church was demolished in 1839 after it had been damaged by heavy snowfall. It was replaced by the current iteration in 1846.

TRINITY CHURCH, CURRENT BUILDING. Designed by Richard Upjohn, Trinity is one of the city's best-known churches and a tourist attraction for anyone visiting Lower Manhattan. This elegant 1898–1900 engraved view of Trinity Church (located at 75 Broadway) was produced by the short-lived H.A. Rost Printing & Publishing Co. of William Street, Manhattan. The company stopped making postcards by 1905. Trinity's postcard popularity at the turn of the 20th century was due in part to its place among the landmarks of the pre-skyscraper city.

TRINITY CHURCHYARD AND SKYSCRAPERS. For decades after it was built, the spire of Trinity Church was the highest structure in the city. By the time this early 20th-century Phostint postcard (manufactured by the Detroit Publishing Company) was published, the church, located on Broadway at Wall Street, was beginning to become dwarfed by its surroundings.

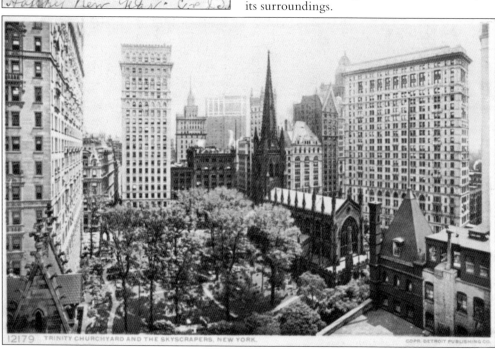

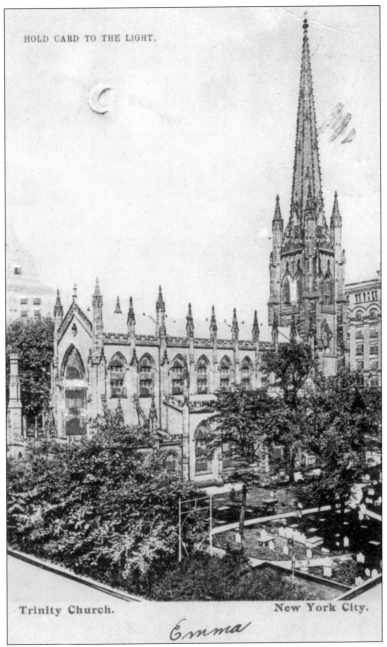

Trinity Church. New York City.

Emma

TRINITY CHURCH HOLD TO LIGHT POSTCARD. In an era with so many postcard manufacturers competing for business in depicting the same city landmarks, gimmicks were employed to sell more postcards. This hold to light card and others like it are triple layered, with certain parts of the top layer die-cut, exposing a second layer of colored tissue paper and a third layer of backing on which to write the address. The result is that when held up to a bright light, the die-cut areas seem to glow warmly. In this c. 1905 postcard, the windows of Trinity Church, as well as the windows of neighboring buildings, are die-cut and underlain with red-, yellow-, and blue-colored tissue paper. The moon is also die-cut but has no tissue paper underneath, resulting in the desired pale yellow hue.

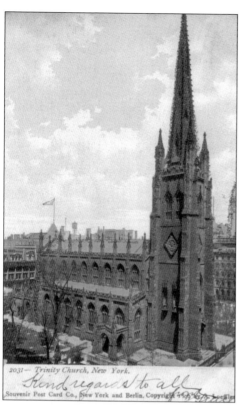

TRINITY CHURCH WITH TINSELING. This 1899 Souvenir Post Card Company view on a 1901–1905 postcard includes tinseling (glitter) along the outline of the building. Tinseling was another gimmick used to sell more postcards. This early Trinity Church view is notable for the fact that no skyscrapers are visible in the background.

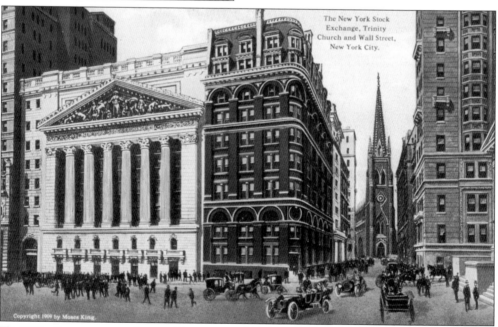

TRINITY CHURCH AND STOCK EXCHANGE. Trinity Church is located in the heart of Lower Manhattan, the oldest part of the city. This 1909 view shows Trinity as seen from Broad Street, with the New York Stock Exchange building in the foreground. While the exchange was founded in 1792, the current stock exchange building dates to 1903.

TRINITY CHURCH WITH COMIC. The effect of this postcard (copyrighted and postmarked in 1908) was more pronounced because of the lack of skyscrapers surrounding Trinity Church at the time. The message on the back from Laurence to Mary is appropriate: "I arrived here this A.M. and there is no end to fun."

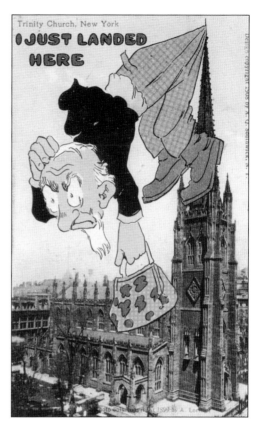

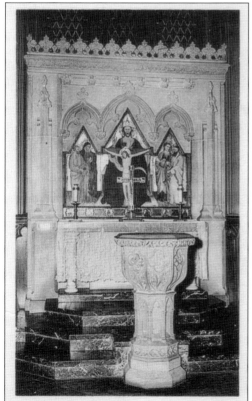

TRINITY CHURCH BAPTISTRY. This Meriden Gravure Company image shows not only the vintage baptistry, but also the altar and reredos, featuring an Italian triptych painting dating to the 14th century. The triptych was presented to the church in 1921 by a vestryman named John Callendar Livingston, who had purchased it in Rome in the last years of the 19th century. The triptych was originally presented by the Tecchini family of Florence to a church in Gubio, in the province of Perugia.

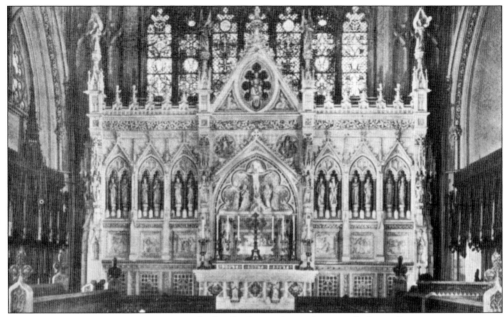

Trinity Church High Altar. The high altar and reredos was dedicated in 1877 in memory of William B. Astor, by his sons John Jacob and William. The altar is made of pure white marble, with shafts of Lisbon red marble dividing its face. The Perpendicular Gothic–style reredos was built of Caen stone and designed by Frederick Clark Withers.

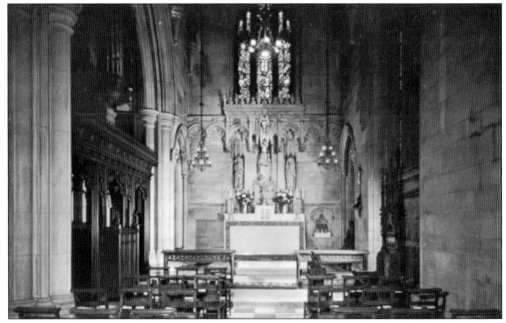

Trinity Church Chapel. The All Saints Chapel, shown here in a 1955 Walter H. Miller and Co. postcard, was designed by Thomas Nash and completed in 1913 as a memorial to the Reverend Dr. Morgan Dix, former rector of Trinity Church from 1862 to 1908.

TRINITY CHURCHYARD CROSS.
This monument, dedicated May 1914, is in the center of the north side of the church yard at Broadway, across from Wall Street. It was presented to Trinity Church by Mrs. Orne Wilson in memory of her mother, Caroline Webster Schermerhorn Astor, wife of William Astor. The cross, also known as the Astor Cross, was designed by the architect Thomas Nash.

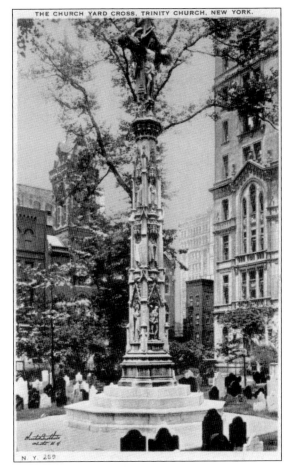

THE CHURCH YARD CROSS, TRINITY CHURCH, NEW YORK.

N Y. 269

OLDEST GRAVESTONE IN TRINITY CHURCHYARD. This stone dates to 1681, and the inscription reads, "Hear lies the body of Richard Churcher the son of William Churcher who deied the 5 of Agus 1681 of age 5 years and 5 months." The stone is in remarkably good shape for its age.

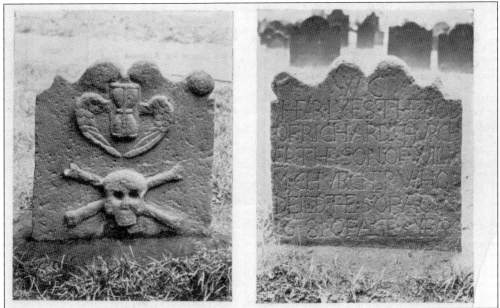

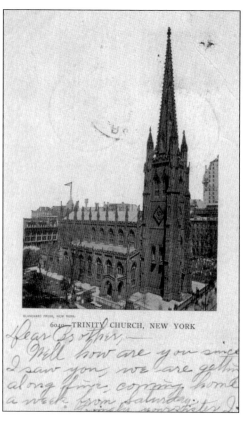

6040—TRINITY CHURCH, NEW YORK

Dear Brother,—
Well how are you since
I saw you, we are getting
along fine, coming home
a week from Saturday.

TRINITY CHURCH AND AMERICAN SURETY BUILDING. In 1896, Trinity got a new neighbor, the 21-story American Surety Building, located at the southeast corner of Broadway and Pine Street, opposite the Trinity Church graveyard. At 312 feet high, it was one of New York's first skyscrapers and the second-tallest building in the city at the time. In the postcard to the left, the American Surety Building is absent from the view. The contrast is marked to the postcard at bottom, which offers the exact same viewpoint.

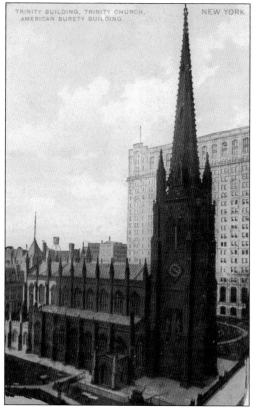

TRINITY BUILDING, TRINITY CHURCH, AMERICAN SURETY BUILDING. NEW YORK

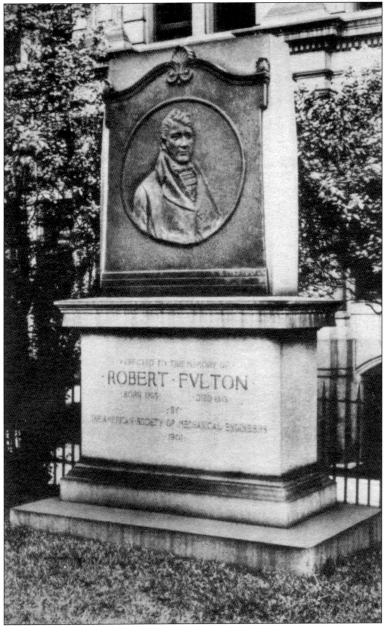

TRINITY CHURCHYARD MONUMENT TO FULTON. Robert Fulton (1765–1815) was a Pennsylvania-born inventor who built the first successful steamboat, the *Clermont*, which made her maiden voyage in 1807 from New York to Albany in a speedy 32 hours. After Fulton died from pneumonia at the age of 49, his funeral service was attended by numerous dignitaries, and thousands of onlookers lined the route from his home to Trinity Church. The impressive monument seen on this Fairtree Press postcard was erected in 1901 by the American Society of Mechanical Engineers. The monument was officially dedicated on December 5, 1901, and the occasion included a sermon given by the Reverend Robert Fulton Crary, Robert Fulton's grandson. The monument does not, however, mark the site of his burial. Fulton was buried in the vault of his wife's family, situated elsewhere in the churchyard.

JOHN STREET METHODIST CHURCH. The current building at 44 John Street is the third church of this name. Founded in 1766, the John Street Church is the oldest Methodist congregation in the United States. Designed in the Greek Revival style, the building was dedicated in 1841 by Bishop Elijah Hedding. The congregation was founded by Philip Embury, who had been converted to the faith by the Methodist founder John Wesley. The first meetings were held in Embury's home.

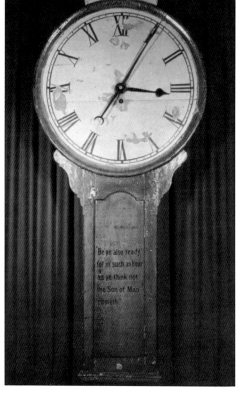

JOHN STREET CHURCH CLOCK. This clock was given to "our first preaching house in America" by Methodist founder John Wesley in 1769. The quote on the clock ("Be ye also ready for in such an hour as ye think not the Son of Man cometh") is from the Bible—Matthew 24:44. The clock is still in working condition.

WESLEY CHAPEL. These postcards depict Wesley Chapel, precursor to the present-day John Street Methodist Church. John Wesley and his British Methodists donated 50 pounds toward "the first Methodist preaching-house in America . . . as a token of brotherly love." The image above is incorrectly labeled as an 1857 view; the scene reproduced on this early-20th-century postcard likely dates to the late 1760s, just after the structure was built in 1768. The mid-20th-century Ektachrome card below shows the chapel as it appeared in 1768, as painted by Joseph B. Smith in 1817. Prior to construction of the first building, the congregation met in founder Philip Embury's home and later in rented space.

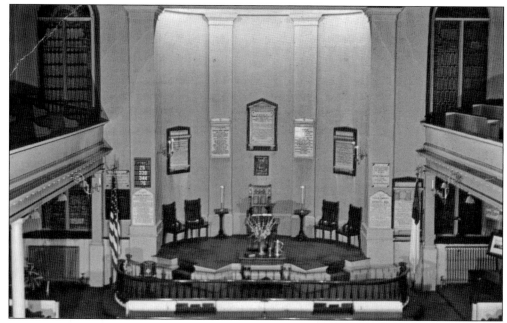

JOHN STREET CHURCH SANCTUARY. The above image dates to 1962, and the image below is undated but probably from around the same time period. On the walls of the sanctuary are tablets dedicated to the memory of Philip Embury, Barbara Heck (Embury's cousin, who is credited with encouraging him to start the church in 1766), Francis Asbury, John Summerfield, Joseph Smith, and other Methodist pioneers. The tablet dedicated to Philip Embury was erected by the Local Preachers' Association of the Methodist Episcopal Church in 1868. The church's pews are trimmed with Santo Domingo mahogany. The current, third church replaced the second one due to the widening of John Street.

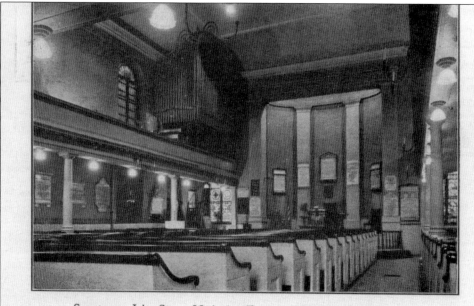

Sanctuary, John Street Methodist Episcopal Church, New York City

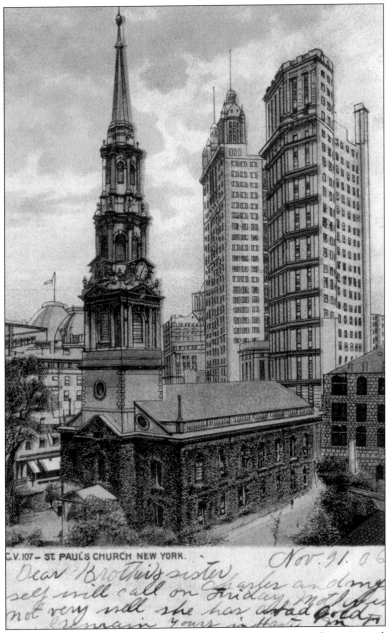

C.V. 107 – ST. PAUL'S CHURCH NEW YORK.

Nov. 91. 06

Dear Brother & sister,
self will call on Friday and am
not very well she has a bad cold
remain yours in Haste

ST. PAUL'S CHAPEL. From the 17th century through the end of the 19th century, church spires were the most prominent feature of the New York City skyline. St. Paul's Chapel (Episcopal) is the oldest-surviving church in New York City that is still used for its original purpose. The first chapel in the Trinity Parish, its spire rises nearly 150 feet high; but by the late 19th century, it was dwarfed by its surroundings. This Georgian–Classical Revival building was designed by Thomas McBean and completed in 1766. The altar and rails were designed by Pierre L'Enfant, who later went on to lay out the city of Washington, DC. The church is located on Church Street between Fulton and Vesey Streets, and for eight months after the 9/11 tragedy, St. Paul's was used as a relief site for emergency workers because of its proximity to the World Trade Center site.

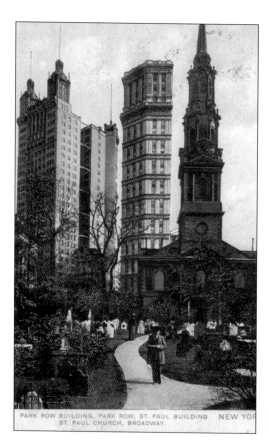

PARK ROW BUILDING, PARK ROW, ST. PAUL BUILDING NEW YOR
ST. PAUL CHURCH, BROADWAY.

ST. PAUL'S CHAPEL AND ST. PAUL BUILDING. The St. Paul Building, located at 220 Broadway, was built in 1898. At 24 stories, it was 315 feet high. The smaller offices in the building were 10 feet wide by 20 feet long; those facing the elevator were 25 feet long. There were six fast-running elevators. Located across from the famous St. Paul's Chapel, the building was demolished in 1958.

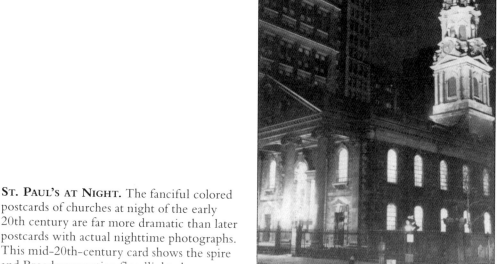

ST. PAUL'S AT NIGHT. The fanciful colored postcards of churches at night of the early 20th century are far more dramatic than later postcards with actual nighttime photographs. This mid-20th-century card shows the spire and Broadway portico floodlighted.

30

St. Paul's Chapel with Comic. This comically enhanced A.Q. Southwick card (see the Trinity Church version on page 21) was copyrighted and postmarked in 1908. The sender added the words "until Tuesday night" to the front and on the back wrote, "Great day for a nice long sleep of course I don't need it!"

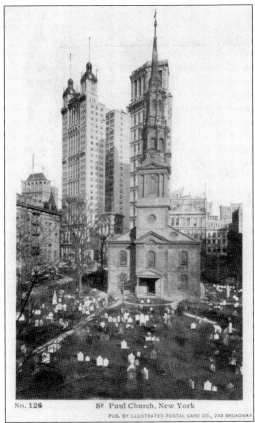

St. Paul's Church and Churchyard. This c. 1900 postcard gives a good view of the St. Paul's churchyard. There are about 800 gravestones in the cemetery. The collapse of the World Trade Center towers in 2001 caused a great volume of dust and debris to be deposited in the churchyard, which reopened in 2003 after a good cleaning.

WASHINGTON'S PEW AT ST. PAUL'S.
Pres. George Washington worshipped at St. Paul's for nearly two years when the nation's capital was located in New York City. Washington and his cabinet and staff attended a service of Thanksgiving at St. Paul's after his inauguration on April 20, 1789. St. Paul's is one of just a handful of remaining buildings in the city that hosted Washington; others included Fraunces Tavern and the Morris-Jumel Mansion in Manhattan.

ST. PAUL'S CHAPEL SILVER. The Communion Silver (chalice with cover and paten) shown on this Albertype postcard was a gift from King George III. St. Paul's is one of just a very few existing New York City churches that predate the American Revolution, with another being the original St. James Church building (no longer a church) in Elmhurst.

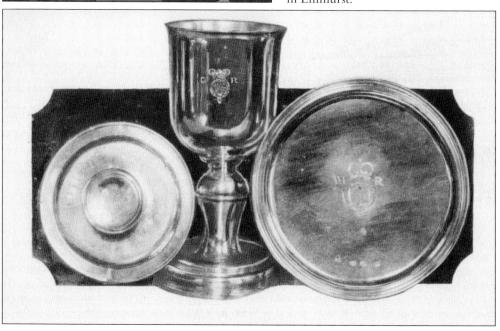

ST. PAUL'S CHAPEL CHANDELIER. This postcard, postmarked 1948, shows one of 14 cut-glass chandeliers. The chandeliers were purchased in 1802, given away in 1856, and purchased back in 1913. They were dismantled and stored for the duration of World War II in the spring of 1942. By 1947, they had been returned to their original places.

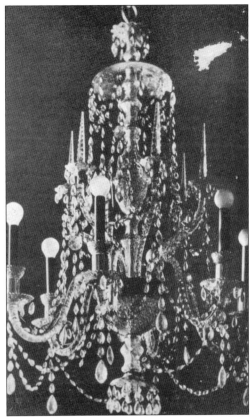

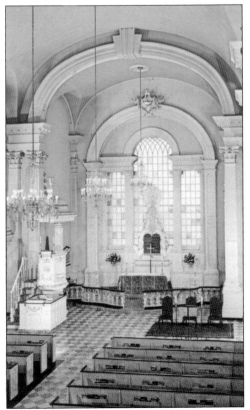

ST. PAUL'S CHAPEL INTERIOR. This Keller Color postcard made by Dexter Press shows the interior of St. Paul's Chapel, including a pulpit with clerk's desk at left; the Neo-Baroque sculpture *Glory,* which depicts the Ten Commandments, designed by Pierre L'Enfant, the planner of Washington, DC; 14 cut-glass chandeliers; and three chancel chairs from the William and Mary period, around 1695.

33

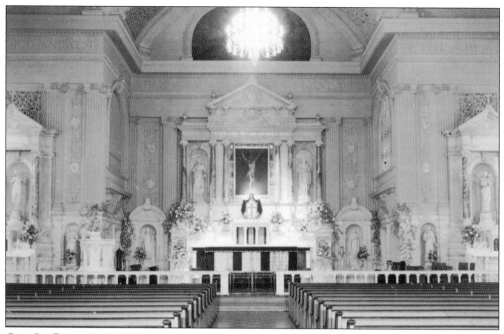

OLD ST. PETER'S CHURCH. When St. Peter's was founded on Barclay Street in Lower Manhattan, there were only 400 Catholics in New York City. The cornerstone was laid on October 5, 1785, by the Spanish ambassador Don Diego de Gardoqui. The first mass was said in the new church on November 4, 1786. St. Peter's was the first Catholic parish in all of New York State. The present, larger Greek Revival structure was completed in 1840 at a cost of $110,000. At one point during the 1860s, there were 20,000 Catholics within parish limits. The infamous Billy the Kid's parents were married at St. Peter's, and he was supposedly baptized there.

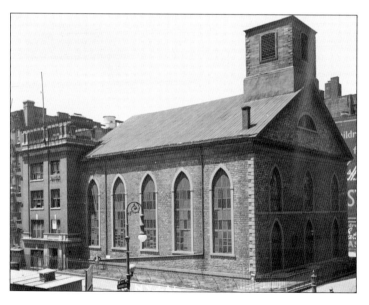

SEA AND LAND CHURCH. Located on Henry Street, this stone building was erected as the Northeast Reformed Dutch Church back in 1819, when the area was still semirural. In 1866, it was transferred to the Presbyterian Church and became known as the Sea and Land Church, as it catered to sailors. It is now the First Chinese Presbyterian Church. It is seen here in a 1936 photograph. (Courtesy of the Library of Congress.)

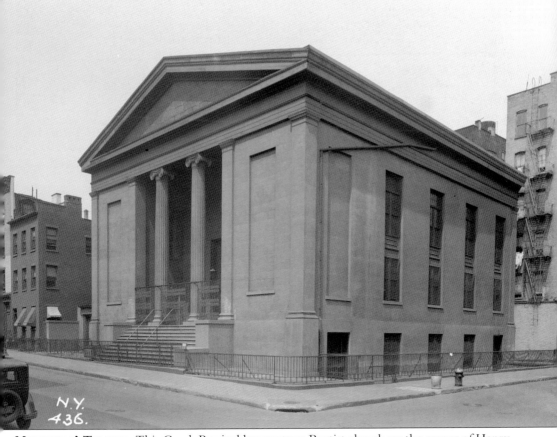

MARINERS' TEMPLE. This Greek Revival brownstone Baptist church on the corner of Henry and Oliver Streets in Lower Manhattan dates to 1844. It is the oldest Baptist church in New York City. The original Baptist church on this site was built in 1795 and burned in 1843. It used to be called the Oliver Street Meeting House before it was acquired by the Mariners' Temple, which was on Cherry Street at the time. The church was founded using funds donated by the philanthropist Henry Rutgers, for whom the New Jersey university is named. Though Rutgers belonged to the Dutch Reformed Church, he donated land and money to Presbyterian and Baptist churches as well. Congregants from Mariners' participated in the March for Jobs and Freedom in Washington, DC, in 1963. The church's name is derived from the fact that it served seamen whose ships were docked on the nearby East River. (Courtesy of the Library of Congress.)

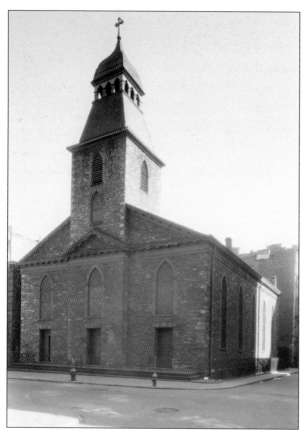

ALL SAINTS' CHURCH. This pair of 1934 photographs depict the interior and exterior of the Episcopal All Saints' Church located at 286–290 Henry Street in Lower Manhattan. The parish was organized in 1824, and the church was completed in 1829. The church, designed by John Heath, may be the only one in the city that has slave galleries, even though slavery was abolished in New York State a year before the church was completed. The church is now called St. Augustine's Episcopal Church. Edgar Allan Poe was one of its parishioners. (Both, courtesy of the Library of Congress.)

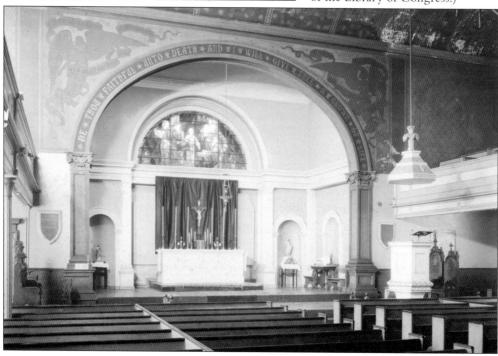

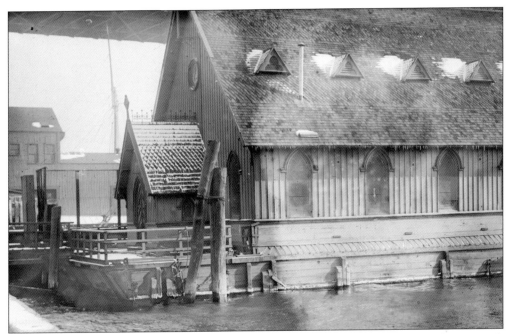

SECOND CHURCH OF OUR SAVIOR. This image depicts a floating church built by the Seamen's Church Institute in 1870 to replace the original, which had been launched in 1844 off Pike Street in Lower Manhattan and burned in 1866. The first building was designed by the well-known architect Richard Upjohn. The second one, shown here around 1900, was in use until 1910. (Courtesy of the Library of Congress.)

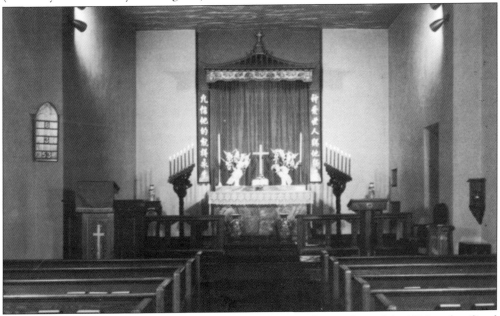

TRUE LIGHT CHINESE LUTHERAN CHURCH. This parish was formed in 1936 and utilized temporary spaces until a run-down old building at 195 Worth Street (at Mulberry Street) in Chinatown was purchased and renovated. The congregation moved into its new home in 1949.

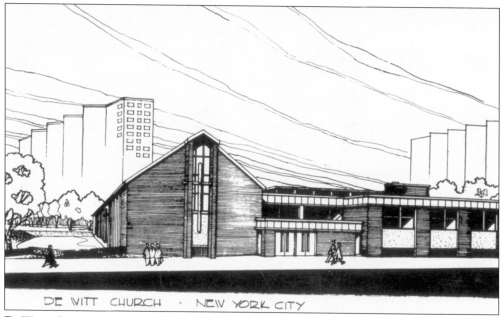

DE WITT CHURCH · NEW YORK CITY

DeWitt Church. This church is located at 280 Rivington Street. Situated within the Baruch Housing Project, it was designed by Edgar Tafel and was sponsored by the New York City Mission Society. The church was first organized in 1854, and the first building on the site was constructed in 1881. The current building dates to 1958.

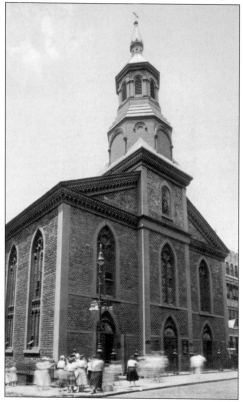

Church of the Transfiguration. This Catholic church at 25 Mott Street is not to be confused with the famous Episcopal one by the same name on Twenty-Ninth Street. Built in 1827, Transfiguration is the fourth-oldest Catholic church in New York City and was originally the Zion Episcopal Church before it was sold. The steeple was added in 1868.

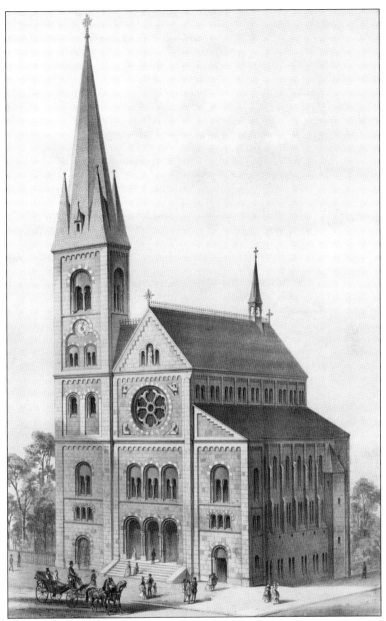

CHURCH OF ST. ALPHONSUS LIGUORI. This Roman Catholic parish was founded in 1847 by the Redemptorist Fathers (also known as the Congregation of the Most Holy Redeemer). The church was named after the founder of the Redemptionists, born in 1696 near Naples, Italy. The Redemptorists were founded in 1732. They first arrived in the United States in 1832. The first Church of St. Alphonsus Liguori, dating to 1847, was located at 10 Thompson Street and was originally a mission of the Church of the Most Holy Redeemer. The second church, depicted here, was located on what was at the time called South Fifth Avenue (now West Broadway), near Canal Street, and was completed in 1872. The church had seating for 2,000 and had two side altars imported from Munich. The Catholic population of the parish in 1913 was 3,700. The building was closed in 1980 and demolished in 1981. It was replaced by the Soho Grand Hotel. (Courtesy of the Library of Congress.)

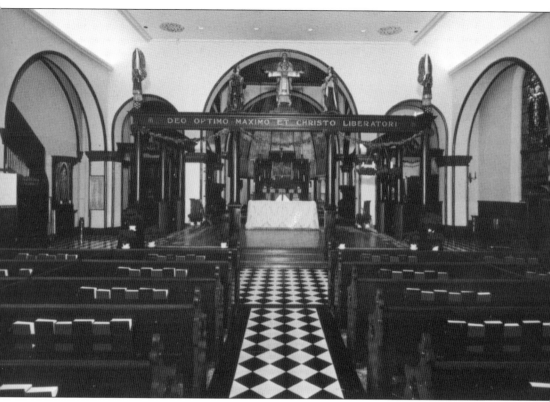

St. Luke's in the Fields. This Greenwich Village Episcopal church was organized in 1820 by a group of locals including Clement Clark Moore, future author of "A Visit from St. Nicholas," at a time when the village was a semirural but quickly growing refuge for New York City residents fleeing north from the rampant and deadly yellow fever epidemics of the time. The first services were held in a prison watchhouse at Hudson and Christopher Streets. Located at 487 Hudson Street (between Christopher Street and Grove Street), the church was begun in 1821 on a site donated by Trinity Church and was consecrated in 1822. It became a chapel of Trinity Church in 1891 and an independent parish again in 1976. In 1956, a school and playground were added adjacent to the church. The church suffered a devastating fire in 1981 and was rebuilt in 1985.

St. Augustine's Chapel. This Victorian-style chapel of Trinity Church was constructed in 1877 on East Houston Street near the Bowery. It catered to the poor immigrants (mainly German in the early years of its existence) who lived in the area. There was a mission house and several educational offerings, including a Sunday school, a day school for boys, a night school for men, a sewing school, and a cooking school. In 1945, it merged with All Saints' Church and moved to Henry Street.

Judson Memorial Baptist Church. Designed by the famed firm McKim, Mead & White, this church was completed in 1893 and is located at 55 Washington Square South. It was originally called the Berean Baptist Church and located on Downing Street, before its expansion. It was named after pastor Edward Judson's father, who was a missionary. (Courtesy of the Library of Congress.)

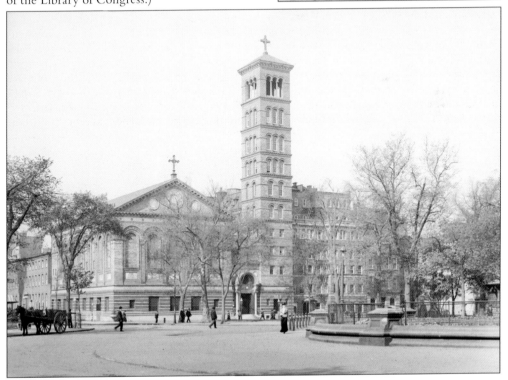

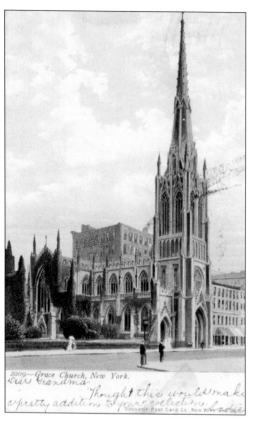

Dear Grandma
a pretty addition to your collection. *Thought this would make*

GRACE CHURCH. Seen from two different perspectives in postcards postmarked in 1905 (left) and 1910 (below), Grace Church was originally located in a building erected in 1808 at Broadway and Rector Streets, near Trinity Church. In 1846, Grace Church moved uptown to its current location at Broadway and Fourth Street, into a Gothic Revival building designed by the 24-year-old architect James Renwick; he destined for future fame, but at this point, he was very early in his career. A rectory was added in 1847. In 1863, Grace Church was the site of the wedding of Tom Thumb and Lavinia Warren. During the 19th century, Grace Church had chapels built on East Twenty-Eighth Street and at two different locations on East Fourteenth Street.

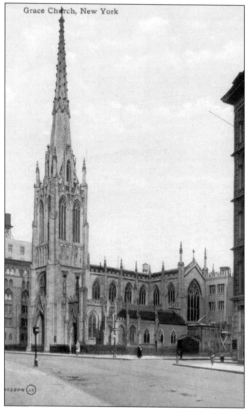

Grace Church, New York

GRACE CHURCH. Restoration work on Grace Church since the early 1990s has included reconstruction of some stonework and the dismantling and reconstruction of the top 30 feet of the stone spire, which was determined to be leaning slightly.

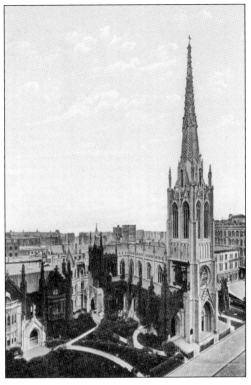

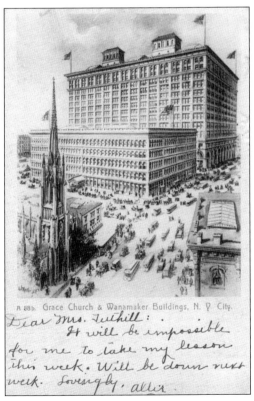

A 88b Grace Church & Wanamaker Buildings, N. Y. City.

*Dear Mrs. Tuthill:
It will be impossible for me to take my lesson this week. Will be down next week. Lovingly, Allie.*

GRACE CHURCH AND WANAMAKER BUILDING. This Rotograph Co. postcard shows Grace Church and its neighbor, the Wanamaker Department Store. The store was located at Fourth Avenue and East Ninth Street. The five-story building to the left of the taller structure was erected as a department store in 1862 by Alexander Stewart. Wanamaker's acquired the store and built the adjacent structure in 1902. The original building was demolished in 1956, but the annex still stands.

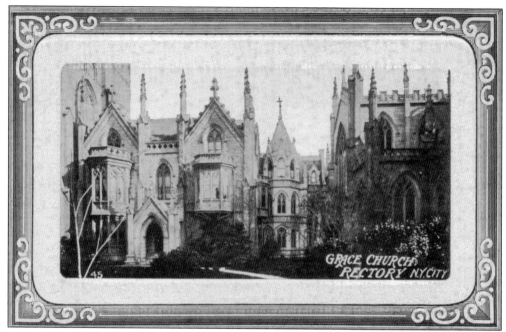

GRACE CHURCH RECTORY. Construction on the Grace Church rectory was begun in 1846 and completed in 1847. Like the church, the rectory was designed by James Renwick, also in the Gothic Revival style. The rectory became a New York City Landmark in 1966.

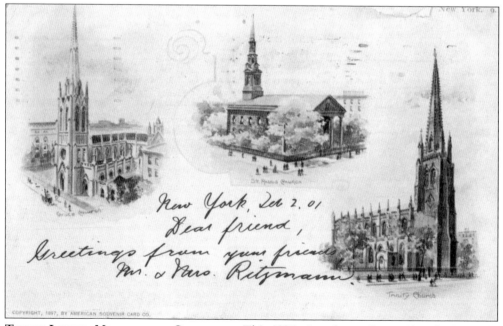

THREE LOWER MANHATTAN CHURCHES. This 1897 view shows Grace Church, St. Paul's Chapel, and Trinity Church in blurry watercolors. It was issued as part of a series of 12 cards of city views by the American Souvenir Card Co., which was only in business from 1897 to 1898.

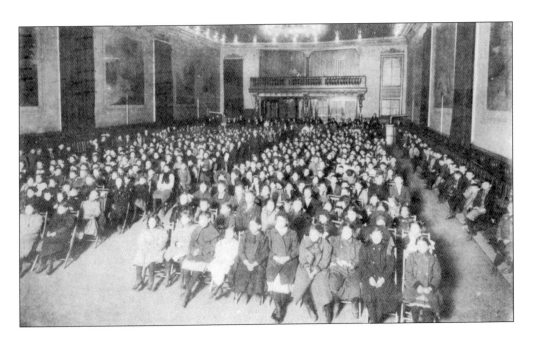

CHURCH OF ALL NATIONS. This Methodist Episcopal church was founded in 1904 with the Wesley Rescue Hall (named after Methodism founder John Wesley) on Houston Street, providing food and shelter for the poor. In 1922, a chapel and neighborhood house were constructed at that location. In 1975, the church moved to St. Marks Place and occupied a building that had been home to the First German Methodist Episcopal Church. After 30 years, the church was combined with others in the area and ceased to exist by this name. The reverse of this postcard (postmarked 1922) tells an interesting story, as shown in the image below.

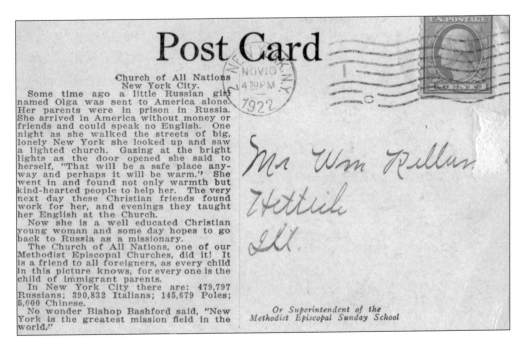

Post Card

Church of All Nations
New York City.

Some time ago a little Russian girl named Olga was sent to America alone. Her parents were in prison in Russia. She arrived in America without money or friends and could speak no English. One night as she walked the streets of big, lonely New York she looked up and saw a lighted church. Gazing at the bright lights as the door opened she said to herself, "That will be a safe place anyway and perhaps it will be warm." She went in and found not only warmth but kind-hearted people to help her. The very next day these Christian friends found work for her, and evenings they taught her English at the Church.

Now she is a well educated Christian young woman and some day hopes to go back to Russia as a missionary.

The Church of All Nations, one of our Methodist Episcopal Churches, did it! It is a friend to all foreigners, as every child in this picture knows, for every one is the child of immigrant parents.

In New York City there are: 479,797 Russians; 390,832 Italians; 145,679 Poles; 5,000 Chinese.

No wonder Bishop Bashford said, "New York is the greatest mission field in the world."

Or Superintendent of the
Methodist Episcopal Sunday School

45

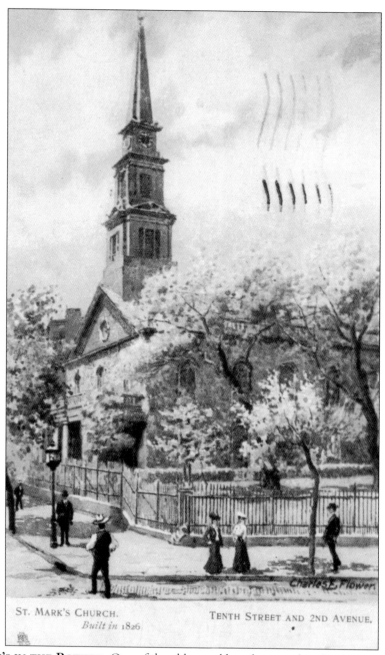

ST. MARK'S CHURCH.
Built in 1826

TENTH STREET AND 2ND AVENUE.

ST. MARK'S IN THE BOWERY. One of the oldest and best-known churches in Manhattan, this structure at Second Avenue and Tenth Street is located on the site of a chapel built by Gov. Peter Stuyvesant adjacent to his manor house in 1660. Stuyvesant was buried in a vault under the chapel in 1682, and British governor Henry Sloughter was buried there in 1691. The chapel became known as Two Mile-Stone Meeting House, as it was located two miles north of the center of town. The chapel was demolished in 1793, and Stuyvesant's grandson then donated the land to the Episcopal Church, along with a sizable amount of cash. St. Mark's Church was built on the site in 1799 and consecrated in 1829. This is a c. 1905 Raphael Tuck & Sons Oilette postcard, featuring an oil painting by Charles E. Flower.

46

ST. MARK'S IN THE BOWERY, 1836.
This mid-20th-century postcard shows
a reproduction of a lithograph that
demonstrates just how rural the St. Mark's
site was for the first decades of the 19th
century. The steeple was added in 1828.
Besides Peter Stuyvesant and Henry
Sloughter, other notables who are buried
there include former New York mayor
Philip Hone and former vice president
Daniel Tomkins.

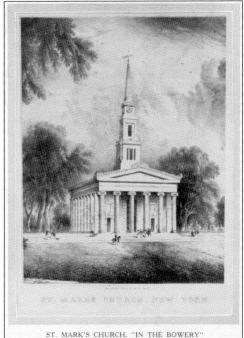

ST. MARK'S CHURCH, "IN THE BOWERY"
As A. J. Davis drew it in 1836

The lithograph by J. B. Kidd is reproduced from the original in
the Eno Collection in The New York Public Library

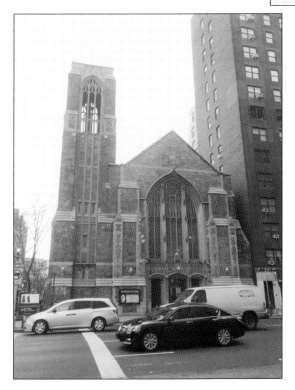

CHURCH OF THE VILLAGE. Though
the building dates back to 1932, this
United Methodist church at 201 West
Thirteenth Street at Seventh Avenue
is the result of the merger of three
churches in 2005: the Church of All
Nations, Metropolitan-Duane United
Methodist Church, and Washington
Square United Methodist Church.
The building at Thirteenth Street is
the former home of the Metropolitan-
Duane church, which originated on
Vestry Street in the 1830s.

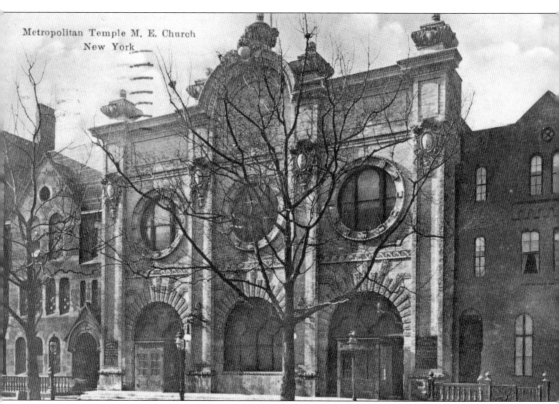

Metropolitan Temple M. E. Church
New York

Metropolitan Temple Methodist Episcopal Church. This church, built in 1856 and located at Seventh Avenue and Thirteenth Street, has since been replaced by a new building and is now known as the Church of the Village. The Metropolitan Temple Church was attended regularly by former president Ulysses S. Grant when he lived in New York in the years before his death in 1885. A special Grant Memorial Window was dedicated in 1908. The central part of the window shows Peace as a winged woman bearing an olive branch poised over a broken shield (and based on the general's words "Let us have peace"), the right side shows a soldier sheathing his sword, and the left side features a mother instructing her child. The Grant family pew in the church was marked by a special commemorative tablet. This postcard was printed by H. Hagemeister Co. in New York and is postmarked 1910. As of 1922, the membership of the church was 809.

Two

MIDTOWN

Midtown has changed so much since the first churches were built there during the early 19th century. From being a semirural area on the outskirts of the city center, to becoming a shopping, residential, office, and tourist destination, Midtown Manhattan rapidly evolved into today's eclectic and diverse mix of neighborhoods. People pass through Midtown by the thousands every day on their way to other parts of Manhattan, commuting by car, bus, and train through the Lincoln Tunnel, Queens Midtown Tunnel, Queensboro Bridge, Port Authority Bus Terminal, Grand Central Station, and Penn Station.

There are dozens of beautiful, historic churches in all corners of Midtown Manhattan, including two of the city's best-known and beloved landmark churches—the Church of the Transfiguration (also known as the Little Church Around the Corner) and St. Patrick's Cathedral.

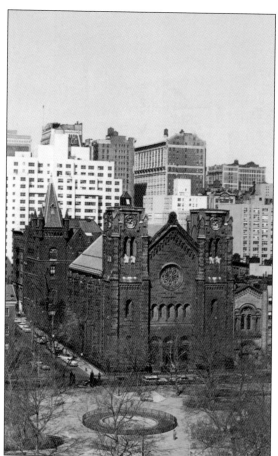

ST. GEORGE'S EPISCOPAL CHURCH. This church is located in Stuyvesant Square at 209 East Sixteenth Street. It was originally a chapel of Trinity Church, built in 1752 and located on Beekman and Cliff Streets. It became its own parish in 1811 and moved to Stuyvesant Square in 1848. A fire in 1865 damaged the steeples, so they were removed and remain missing to this day. By the 1890s, it had 2,600 communicants, making it one of the largest Episcopal congregations in the country. In 1976, St. George's merged with two other Episcopal congregations, Calvary and Holy Communion, and the building is today known as Calvary and St. George's Church. The postcard to the left dates to around 1960s, and the 1909 postcard below shows the interior of the church.

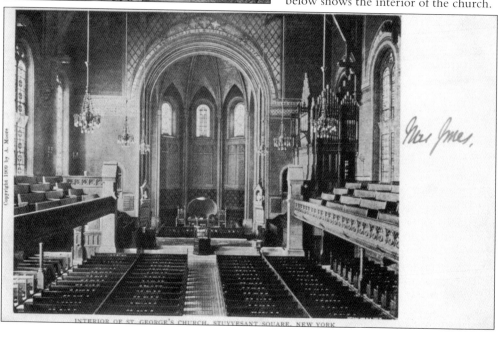

INTERIOR OF ST. GEORGE'S CHURCH, STUYVESANT SQUARE, NEW YORK

50

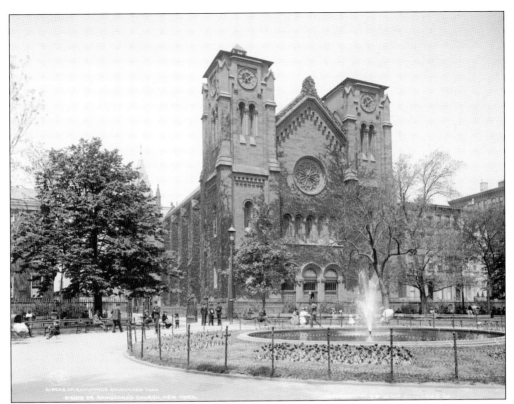

DR. RAINSFORD'S CHURCH. St. George's was also known as Dr. Rainsford's Church during the tenure of its rector William Rainsford (from 1882 to 1906). The church is shown here in a c. 1905 photograph. Rainsford was well known and during his time at St. George's wrote four books. He went on to write three more before his death in 1933. (Courtesy of the Library of Congress.)

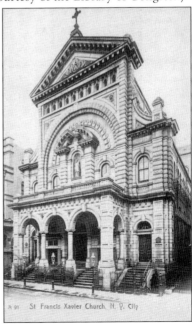

ST. FRANCIS XAVIER CHURCH. Shown here in a c. 1900 view, this building at 30 West Sixteenth Street is the third St. Francis Xavier Church. The first was destroyed in a fire in 1848, and the Roman Catholic congregation outgrew the second church by the 1870s. The cornerstone of the present structure was laid in 1878 before a crowd of 5,000 people, and the building was completed in 1882 at a cost of about $600,000. The Jesuit church was designed by the well-known Irish architect Patrick Keely.

ST. PETER'S CHURCH. Built in 1832 (the rectory, which was originally the chapel) and 1838 (the current sanctuary), this Episcopal church at 436 West Twentieth Street is a neighborhood landmark. Seen in a 1934 photograph, the Gothic Revival church was built on land donated by the author of "A Visit from St. Nicholas," Clement Clark Moore, whose family owned the property. Moore's father, Benjamin, had been rector at Trinity Church. (Courtesy of the Library of Congress.)

Looking west from roof of Home Office of the Metropolitan Life Insurance Company of New York. Madison Square in the foreground.

MADISON SQUARE PRESBYTERIAN CHURCH STEEPLE. This pre–1907 postcard was issued with compliments of the Metropolitan Life Insurance Company and depicts the view looking west from the roof of the company's headquarters building between Twenty-Third and Twenty-Fourth Streets. It shows the prominence of the original Madison Square Church in the days before the MetLife Tower came into existence. The steeple, along with the tower of the old Madison Square Garden building two blocks north on Twenty-Sixth Street, dominated the skyline of the area. Just a few years after this postcard was issued, the church would be demolished and the new Metropolitan Life Building would stand on that spot.

MADISON SQUARE PRESBYTERIAN CHURCH. Constructed in 1854 and designed by Richard M. Upjohn, this Gothic Revival church sat on Twenty-Fourth Street, across from Madison Square Park. It was more commonly known as Dr. Parkhurst's Church after its leader, the powerful and respected Rev. Dr. Charles H. Parkhurst. By the 1890s, the Metropolitan Life Company had erected a headquarters building directly adjacent to the church. Within about 10 years, the company wanted to expand, and the church stood in its way. The president of Metropolitan Life bought the land directly north and across Twenty-Fourth Street from the existing building and offered the site to Dr. Parkhurst, along with some additional monetary incentive. He reluctantly agreed, and commissioned Stanford White to design the new church. The new building was modeled after a Roman basilica, with a dome and columns. For a very brief period, both the old church and the new coexisted.

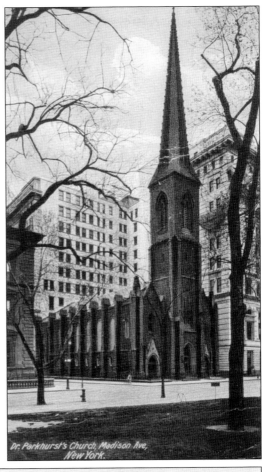

Dr. Parkhurst's Church, Madison Ave, New York.

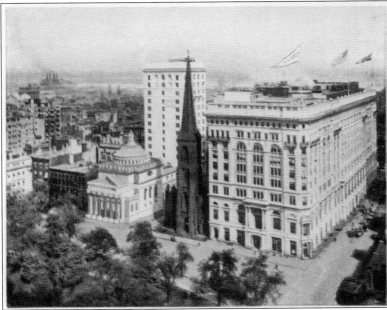

Metropolitan Life Insurance Co.'s Home Office Bldg., N. Y. City, with annex at the left, back of the new church of the Rev. Dr. Parkhurst. Largest office building in the world. Contains more elevators and typewriting machines than any building in the world

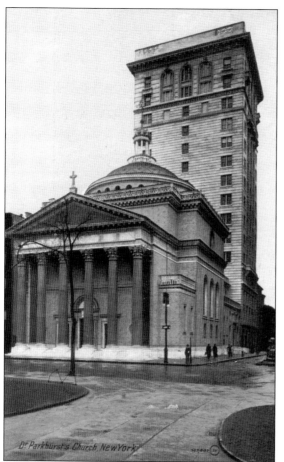

Dr Parkhurst's Church New York

METLIFE TOWER WITH NEW CHURCH. The old Madison Square Presbyterian Church was inevitably demolished and the new MetLife tower constructed. Completed in 1909, it was the world's tallest building until the completion of the Woolworth Building in 1913. The glorious new 1906 church, hailed by many as an architectural masterpiece, did not last very long at all. Just a dozen years after it was built, the church combined with other nearby Presbyterian churches, and the land was sold to MetLife. The beautiful building was demolished in 1919, with some of its elements salvaged and reused in other structures. The MetLife Building annex occupies the site today.

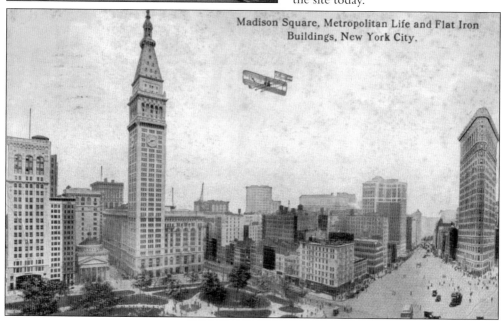

Madison Square, Metropolitan Life and Flat Iron Buildings, New York City.

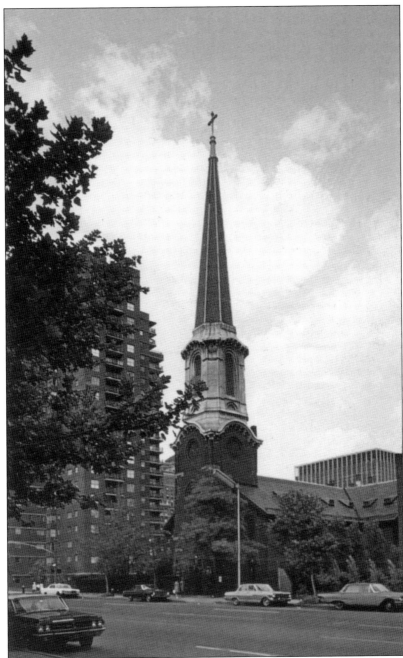

CHURCH OF THE HOLY APOSTLES. The church traces its origins to a Sunday school founded in the 1830s. The original 1848 Episcopal structure at 300 Ninth Avenue (Twenty-Eighth Street) still survives today. Designed by Minard Lafever (with stained-glass windows by William and John Bolton), the church was enlarged by 24 feet eastward in 1854. Transepts were added in 1858. In 1908, the wooden spire was covered with slate. Legend has it that the church was once a stop on the Underground Railroad. The building was named a New York City Landmark in 1966. A fire in 1990 did major damage to the roof, ceiling, and windows. The restored church reopened in 1994. It is seen here on a c. late-1960s postcard.

Hotel Seville, Fifth Ave. and Twenty-ninth St., New York. John F. Garrety, Manager.

Single Rooms $2.50 per Day, Room with Bath $3.00 upward.

ST. LEO'S CHURCH. This c. 1920s postcard for the Hotel Seville at Fifth Avenue and Twenty-Ninth Street denotes three area churches: Marble Collegiate Church, the Little Church Around the Corner, and St. Leo's Roman Catholic Church. The latter, located at 10 East Twenty-Ninth Street, was a Gothic Revival structure built in 1881. St. Leo's was built to relieve overcrowding at nearby St. Stephen's Church. The new church had a mortuary chapel at 9 East Twenty-Eighth Street that was intended for the reception of those who died while visiting New York until they could receive services at churches of their own faiths. St. Leo's was led by the Reverend Thomas J. Ducey, who continued in charge until his death in 1909. Shortly after, the church was given to the Sisters of Marie Reparatrice upon their exile from France and became their convent chapel; the rectory became their convent. The building was demolished in 1985.

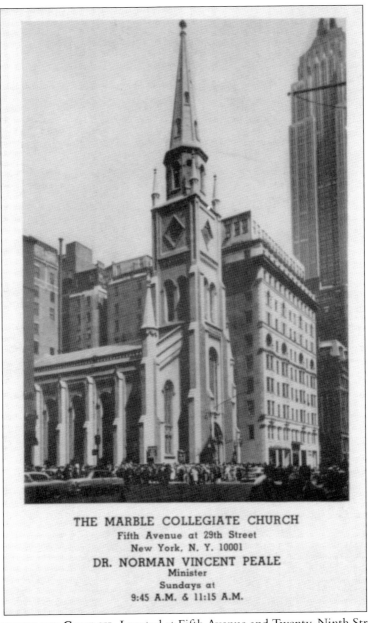

THE MARBLE COLLEGIATE CHURCH
Fifth Avenue at 29th Street
New York, N. Y. 10001
DR. NORMAN VINCENT PEALE
Minister
Sundays at
9:45 A.M. & 11:15 A.M.

MARBLE COLLEGIATE CHURCH. Located at Fifth Avenue and Twenty-Ninth Street, just four blocks south of the Empire State Building, the Marble Collegiate Church, part of the Dutch Reformed Church, traces its roots all the way back to 1628 and the early days of New Amsterdam. The first Marble Collegiate Church service in the city was conducted in a gristmill at what was then the southern tip of Manhattan Island. In 1633, the first dedicated church building was constructed. Others that followed included the Garden Collegiate Church, the Middle Collegiate Church, and the North Church. The building depicted here was designed by Samuel A. Warner and built in 1854 at a time when the area around Twenty-Ninth Street was mainly rural. The marble used for the church came from Hastings-on-Hudson, New York. This postcard refers to the highly respected Norman Vincent Peale, who was the author of the bestselling *The Power of Positive Thinking*, which sold more than 20 million copies.

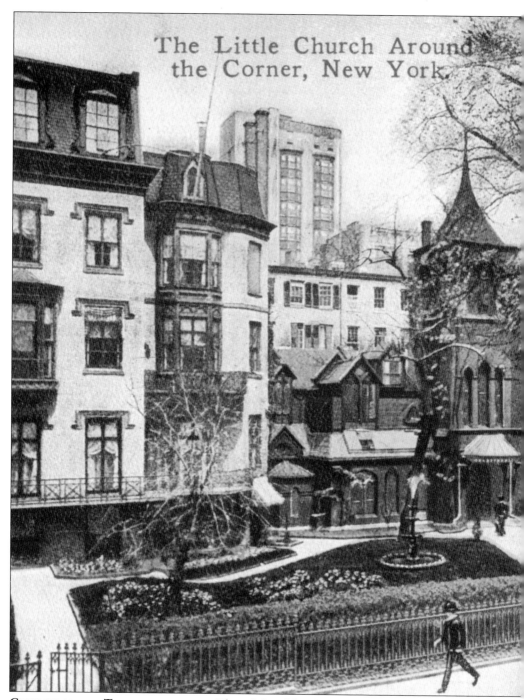

CHURCH OF THE TRANSFIGURATION. The origin of the church's more well-known name, the Little Church Around the Corner, dates back to 1870, when the actor Joseph Jefferson approached the pastor of a nearby church to ask if he could hold a funeral service for a fellow actor named George Holland, who had just died. The pastor refused, telling Jefferson to go to "the little church

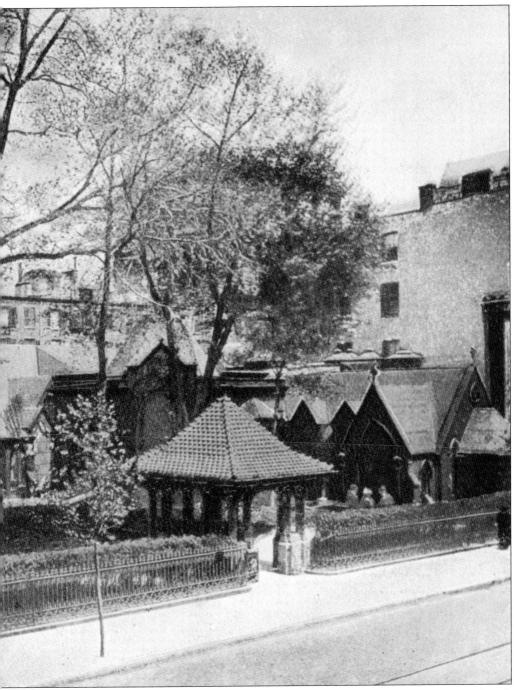

around the corner" instead. Jefferson's replied, "Then I say to you, sir, God bless the little church around the corner." The name caught on, and according to an 1892 guidebook, "This simple incident has made the church an object of affectionate regard to the whole dramatic profession." The church has been the headquarters of the Episcopal Actors' Guild since 1923.

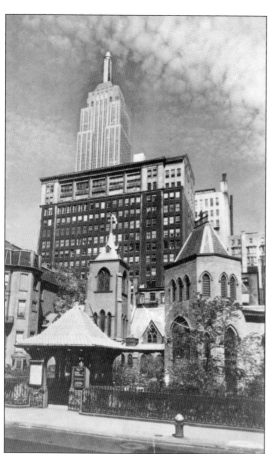

CHURCH OF THE TRANSFIGURATION.
The church was founded in 1848 by Rev. George Hendric Houghton, who was its rector for nearly 50 years. Houghton was a legendary figure who established the church's reputation for embracing all people. Built in 1850, and expanded in the decades that followed, this Episcopal church, like its nearby neighbor the Marble Collegiate Church, was in the midst of a semirural area when it was first constructed.

CHURCH OF THE TRANSFIGURATION WITH NOTE. This colorized real-photo postcard, postmarked in 1908 and mailed to a Ben in Maine, has a note written on the front: "This is 'The Little Church Around the Corner.' Suppose you have heard of it. It is quite an interesting place."

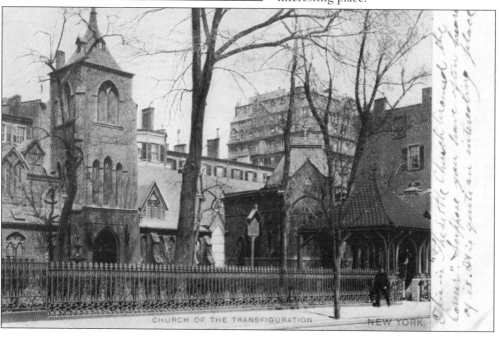

CHURCH OF THE TRANSFIGURATION IN WINTER. Of all Manhattan churches, the Church of the Transfiguration, also known as the Little Church Around the Corner, seems to have the most consistently romantic and picturesque postcard views published over the years. In fact, the church website features a vintage postcard view on its "About Us" page. This 1903 William Randolph Hearst view shows a snow-covered scene.

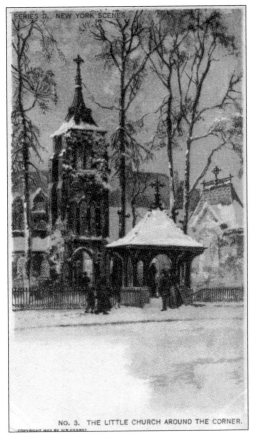

NO. 3. THE LITTLE CHURCH AROUND THE CORNER.

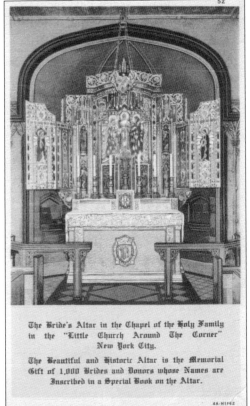

The Bride's Altar in the Chapel of the Holy Family in the "Little Church Around The Corner" New York City.

The Beautiful and Historic Altar is the Memorial Gift of 1,000 Brides and Donors whose Names are Inscribed in a Special Book on the Altar.

CHURCH OF THE TRANSFIGURATION BRIDE'S ALTAR. This C.T. Art Colortone linen postcard by Curt Teich and Co. shows the Bride's Altar in the Chapel of the Holy Family. The altarpiece depicts the betrothal of Mary and Joseph. This intimate chapel has been the site of tens of thousands of marriages.

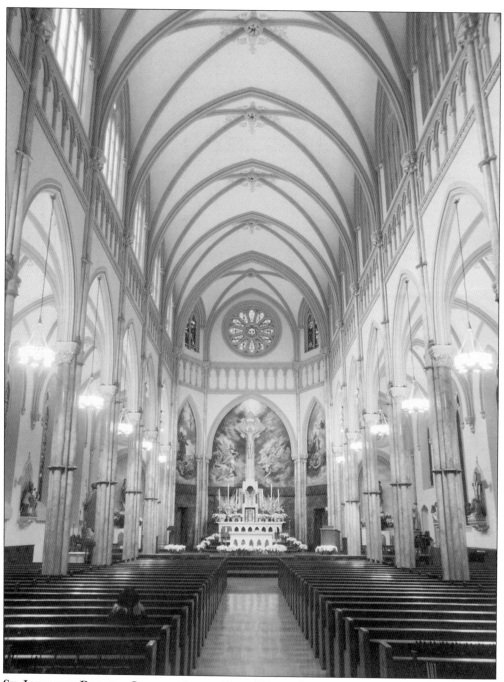

ST. JOHN THE BAPTIST CHURCH. Located just off Seventh Avenue at 211 West Thirtieth Street, this church is the third iteration of St. John the Baptist in this general vicinity (the first being on West Thirty-First Street and the second on West Thirtieth Street closer to Sixth Avenue). The parish was formed in 1840 to serve German Catholics who lived in the area at the time. This Gothic Revival building dates to 1870. The neighborhood has evolved greatly in the years since the church's construction, and is now part of the busy Fashion District. Once Penn Station was built across the street, the church was suddenly in a highly visible location.

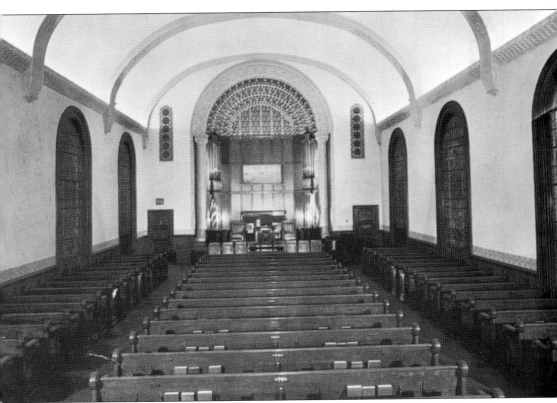

MADISON AVENUE BAPTIST CHURCH. Originally organized with 12 members as the Rose Hill Baptist Church in 1848 (named after the section of Manhattan), the congregation erected a church at Lexington Avenue and Thirtieth Street in 1849 and changed its name to the Lexington Avenue Baptist Church. In the 1860s, a new church was erected on five lots at Madison Avenue and Thirty-First Street, and the name changed to the Madison Avenue Baptist Church. The building was demolished in 1930, and the Roger Williams Hotel (containing a new home for the church inside) was built in its place. This postcard shows the space within the hotel (which was named after the founder of the first Baptist church in America). The church's original stained-glass windows were preserved inside the new space in the hotel.

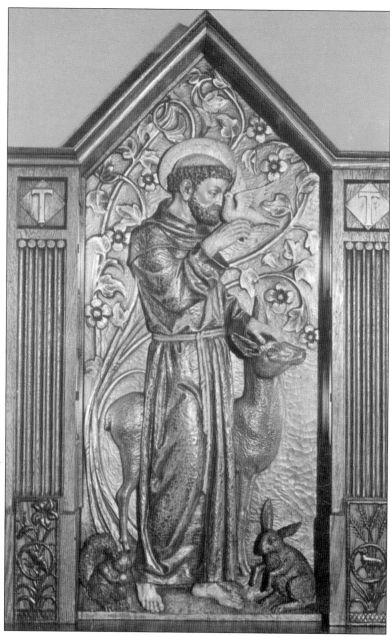

ST. FRANCIS OF ASSISI CHURCH. The first St. Francis Church on this site at 135 West Thirtieth Street, off Seventh Avenue, was built in 1844 after nearby St. John the Baptist was (temporarily) closed. Its first pastor was Fr. Zachary Kunz, a Hungarian Franciscan priest who had formerly been pastor of St. John the Baptist. The St. Francis parish outgrew its building in less than 50 years, and a new church was completed in 1892. As the neighborhood demographics shifted from residential to commercial during the 20th century, the church focused on serving workers, shoppers, and tourists. It was the first Catholic church in the United States to have permission to hold mass after noon, catering to employees on their lunch hour. This c. 1955 postcard features a carved wood image of St. Francis of Assisi, Patron of Animals. The church was renovated in the late 1950s.

ST. FRANCIS OF ASSISI CHURCH MOSAIC. The Great Mosaic of the Sanctuary was completed by the Tyrolese Institute of Glass Painting and Mosaic, with Rudolph Margreiter and Joseph Wild in charge of the design and installation. Depicting Mary standing on a globe of the world, it was completed in 1925. Interestingly, the mosaic scene depicted on this postcard is not the Great Mosaic but one of the other, smaller ones elsewhere in the church.

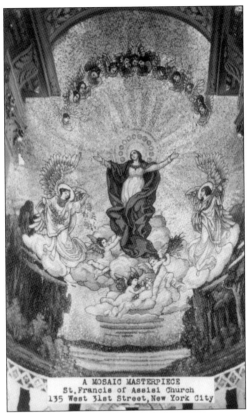

A MOSAIC MASTERPIECE
St. Francis of Assisi Church
135 West 31st Street, New York City

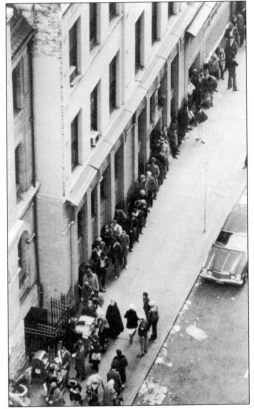

ST. FRANCIS OF ASSISI BREADLINE. When the Great Depression began in 1929, the church began to feed the poor with a daily breadline. This c. early 1970s postcard demonstrates the enduring popularity of the breadline, which continues to this day.

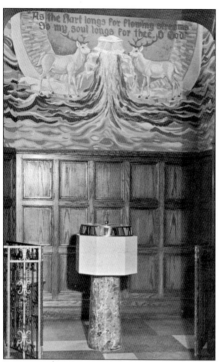

ST. FRANCIS OF ASSISI BAPTISTRY. This postcard offers a detailed view of the Baptistry at St. Francis of Assisi. The church lost one of its beloved Franciscan Friars on 9/11 when Fr. Mychal Judge, a chaplain of the New York City Fire Department, became the first officially recorded fatality at the World Trade Center.

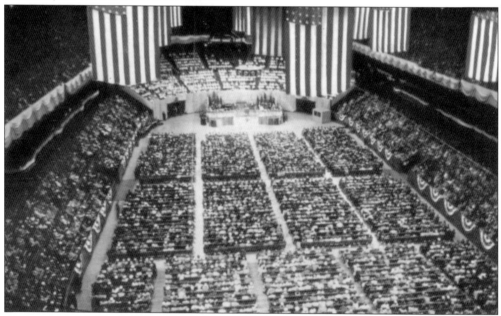

BILLY GRAHAM CRUSADE AT MADISON SQUARE GARDEN. Over the years, the evangelical Christian minister Billy Graham conducted over 400 "crusades" around the world, preaching to countless thousands of people in large arenas. He held three crusades at Madison Square Garden, the longest of which was in 1957, when he appeared there for 16 weeks, holding 100 services and drawing two million people. He returned to the Garden in 1960 (a three-day event for Spanish-speaking people) and 1969. This postcard dates to his third New York crusade in 1969, which took place in June and July.

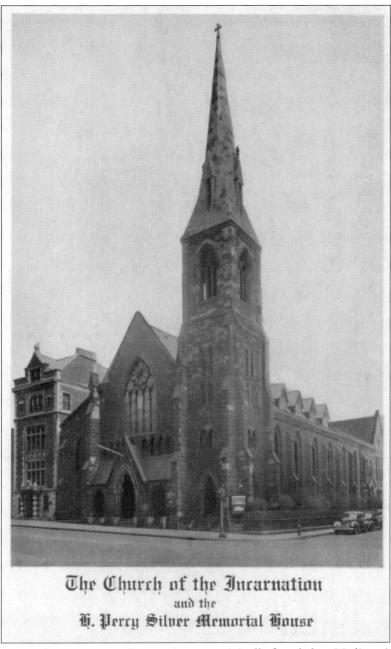

The Church of the Incarnation
and the
H. Percy Silver Memorial House

CHURCH OF THE INCARNATION. Incarnation was originally founded on Madison Avenue and Twenty-Eighth Street as a mission chapel of Grace Church. The independent Episcopal parish was founded in 1852, and the dark sandstone church shown in this Lumitone Photoprint image opened in 1864 at Madison Avenue and Thirty-Fifth Street, a year after Incarnation opened its own mission chapel on East Thirty-First Street (now known as the Church of the Good Shepherd). The Church of the Incarnation was restored and enlarged following a devastating fire in 1882 that melted all the stained glass and completely destroyed the eastern side of the church. The spire was added to its square tower in 1896. The funeral for Pres. Franklin Delano Roosevelt's mother Sara Delano Roosevelt was held at this church in 1941.

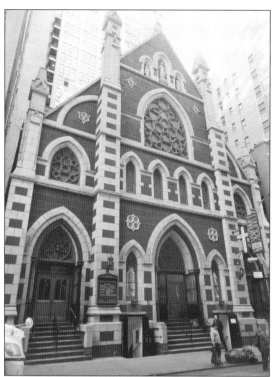

CHURCH OF THE HOLY INNOCENTS. This elaborately stylized Gothic Revival Roman Catholic church was built on the south side of Thirty-Seventh Street near Broadway in 1870. At the time, the area was still semirural, but things soon changed as development caught up. The playwright Eugene O'Neill was baptized in Holy Innocents in 1888.

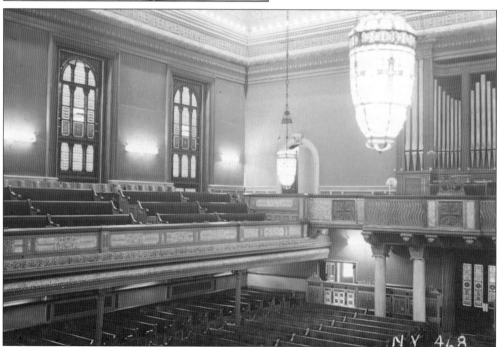

BRICK CHURCH INTERIOR. This 1937 photograph shows the ornately detailed interior of the 1858 version of the Brick Church, located on Fifth Avenue at Thirty-Seventh Street. The old building was demolished in 1938 after the property was sold, and the church moved uptown. (Courtesy of the Library of Congress.)

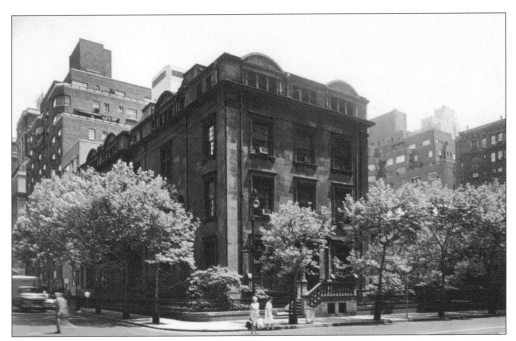

LUTHERAN CHURCH HOUSE. This building, located at 231 Madison Avenue (corner of Thirty-Seventh Street), was originally built in 1853. In 1904, it was purchased by the famous financier J.P. Morgan, whose own mansion was on the corner of Thirty-Sixth Street and Madison Avenue, for his son Jack. After Jack died in 1943, the family sold the building to the United Lutheran Church in America. The Lutheran Church built an adjacent five-story addition in 1957. The former Morgan brownstone served as Lutheran headquarters for over four decades, until the adjacent Morgan Library purchased the property back in 1988. In 1991, a Garden Court was opened, which connects 231 Madison with the Morgan Library complex. The postcard above shows a Madison Avenue view, and at right is a Thirty-Seventh Street view (with the addition on the left). Both of these Colorcraft Studios cards date to around 1960.

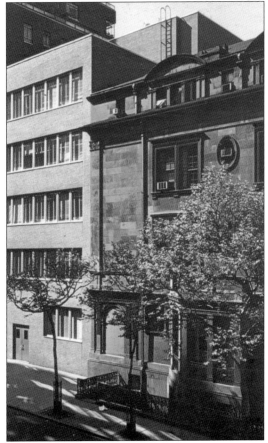

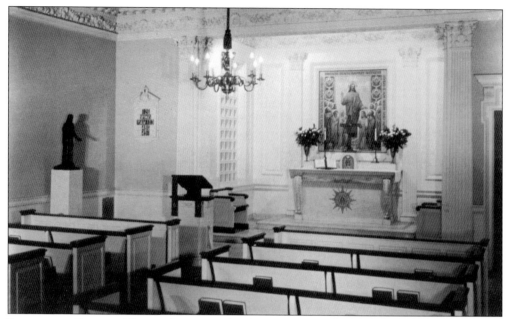

LUTHERAN CHURCH HOUSE CHAPEL. This "Natural Color" postcard by Dexter Press (issued by the Department of Press, Radio and Television of the United Lutheran Church in America) shows the small chapel within the Lutheran Church House at 231 Madison Avenue. Interestingly, Dexter Press was located just a block away at 274 Madison Avenue.

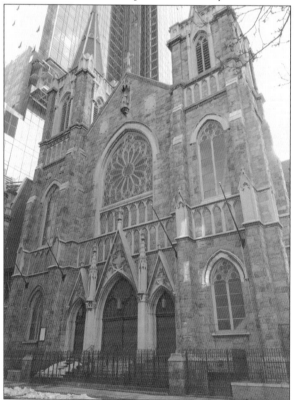

CHURCH OF SS. CYRIL AND METHODIUS. This church, which is now a Croatian parish, occupies a building that used to be the Roman Catholic Church of St. Raphael. Located on Fortieth Street between Tenth and Eleventh Avenues, St. Raphael was built in 1903 for Irish immigrants, on a site that had been used as temporary quarters for the church since 1886. During the 1970s, the building was taken over by Croatians who had previously worshipped in a small church on West Fiftieth Street.

METRO BAPTIST CHURCH. Founded in 1974 on the Upper West Side, Metro Baptist moved to its current home in 1984. Located at 410 West Fortieth Street (between Dyer Avenue and Ninth Avenue), the building seen in this photograph was erected in 1913 and was formerly the home of the St. Clemens Mary Polish-Catholic Church. The St. Clemens parish was formed in 1909. The first mass was said in a candy store on Tenth Avenue near Fifty-First Street, then a Lutheran church on West Fiftieth Street near Eleventh Avenue was rented. Finally, four lots on West Fortieth Street were purchased, and work on the building, designed by Fred Schwartz of Paterson, New Jersey, began. At the time, the church contained relics of St. Clemens. As of 1914, the church had 3,000 parishioners and the school had about 120 children.

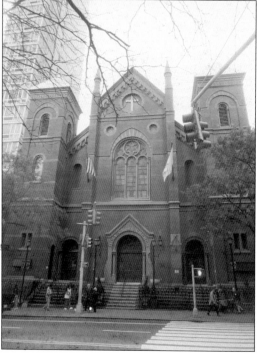

CHURCH OF THE COVENANT. This Presbyterian church was founded in 1860, and the original building constructed in 1865 at Park Avenue and Thirty-fifth Street. This 1966 photograph depicts the Gothic Revival Memorial Chapel at 310 East Forty-Second Street that originally served as a mission church to the original church. (Courtesy of the Library of Congress.)

HOLY CROSS CHURCH. Located at 333 West Forty-Second Street, off Eighth Avenue, this Roman Catholic church is across the street from the Port Authority Bus Terminal. The building dates to 1870 (expanded in 1885), making it one of the oldest on a street that is traditionally in flux. This church was home to the famous World War I chaplain of the "Fighting 69th" Infantry Regiment, Fr. Francis Duffy, a statue of whom is located in Times Square, between Broadway and Seventh Avenue at Forty-Sixth Street.

PORT SOCIETY STATION. While the Seaman's Church Institute of New York had its main location at 25 South Street, it opened up a Port Society Station at 524 West Forty-Second Street between Tenth and Eleventh Avenues near the Hudson River (shown on this postcard) and a Port Newark Station at Calcutta and Export Streets in Newark, New Jersey.

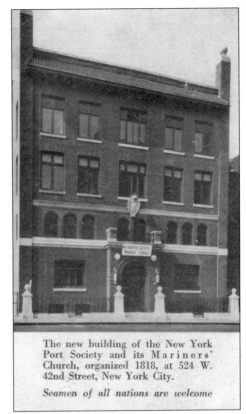

The new building of the New York Port Society and its Mariners' Church, organized 1818, at 524 W. 42nd Street, New York City.

Seamen of all nations are welcome

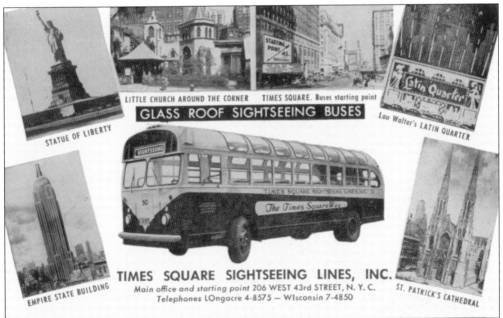

STATUE OF LIBERTY

LITTLE CHURCH AROUND THE CORNER TIMES SQUARE. Buses starting point

GLASS ROOF SIGHTSEEING BUSES

Lou Walter's LATIN QUARTER

EMPIRE STATE BUILDING

TIMES SQUARE SIGHTSEEING LINES, INC.
Main office and starting point 206 WEST 43rd STREET, N. Y. C.
Telephones LOngacre 4-8575 — WIsconsin 7-4850

ST. PATRICK'S CATHEDRAL

SIGHTSEEING BUS. Churches such as St. Patrick's have always been a popular tourist destination. This early-1940s tour bus company postcard features two churches. The reverse says, "For the past decade we have carried millions of visitors who have enjoyed our various tours."

GOSPEL TABERNACLE CHURCH. A walk through the front door of the unassuming building at 260 West Forty-Fourth Street leads to a large interior space that used to house the Gospel Tabernacle Church, which was organized in 1882 and began at this location in 1890. The front part of the building contained a missionary training college. In 1997, the building was converted into a branch of John's Pizzeria, a West Village pizzeria that had been in business since 1929. The interior still preserves a large stained-glass eight-sided dome, as well as the balcony that used to offer church seating. At the time of its opening, John's was the largest pizzeria in New York City, with a seating capacity of 400 people.

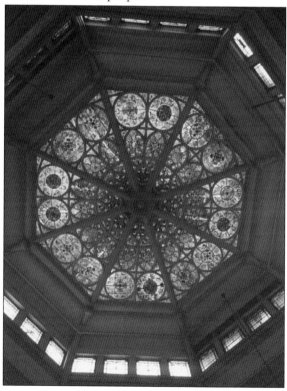

CROSSROADS SEVENTH-DAY ADVENTIST CHURCH. The building at 410 West Forty-Fifth Street, off Ninth Avenue in Hell's Kitchen, has had a long history of use by a number of different congregations. The building was originally the Fourth German Mission Reformed Church in 1903 and then the Third Moravian Church before it became Crossroads Seventh-day Adventist, which moved from West Seventy-Ninth Street to its current location.

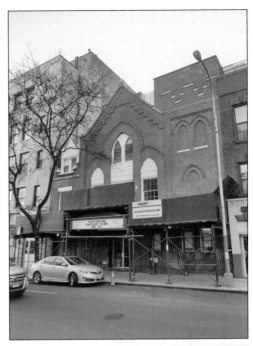

ST. CLEMENT'S CHURCH. The sanctuary of this Episcopal church at 423 West Forty-Sixth Street was converted into an Off-Broadway theater in 1962, but it still functions as a church, offering mass on Sundays. The building was completed in 1872 in the Victorian Gothic style, as a chapel of the West Presbyterian Church.

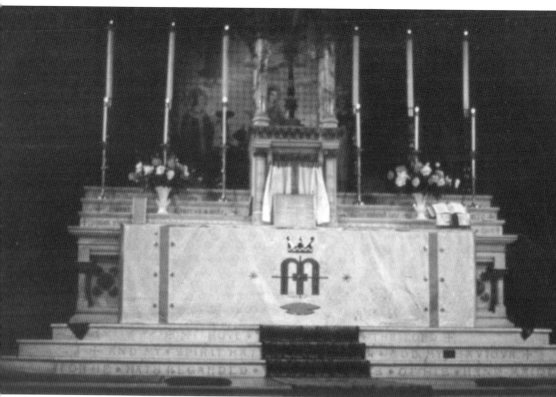

CHURCH OF ST. MARY THE VIRGIN. This Episcopal church was originally located at 228 West Forty-Fifth Street, a block south and a block west from its present site at 145 West Forty-Sixth Street. It was built on land donated by John Jacob Astor Jr. Ground breaking took place in 1868, and the church was completed in 1870. Within a couple of decades, the congregation outgrew the original 1870 building and bought land nearby for a new, larger church at a price of $220,000. An architectural competition was held, with 12 specific stipulations, including that the church had to be designed in the French Gothic style and had to seat at least 800 people. The cornerstone for the new building was laid in 1894, and the church was completed in 1895. Just a decade or so after the new church building was completed, the area began to gain a reputation as the city's latest theater district.

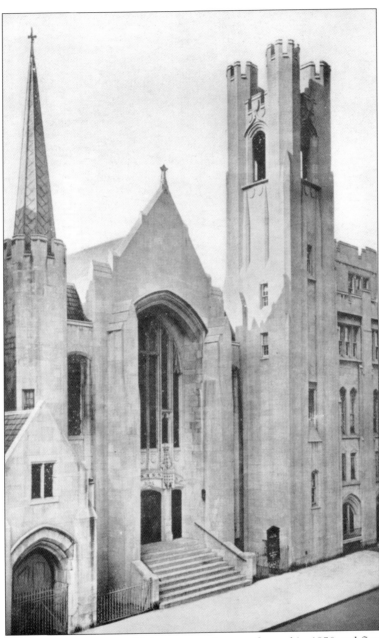

St. Luke's Lutheran Church. This congregation was formed in 1850 and first met on the third floor of a building at Ninth Avenue and Thirty-Fifth Street, and after a move to Eighth Avenue at Forty-Sixth Street, the church took over a former Baptist church on Forty-Third Street in 1863. When it outgrew the Forty-Third Street building, it then moved to larger quarters at 233 West Forty-Second Street, into a building that was formerly the Forty-Second Street Presbyterian Church. Finally, in 1922, construction was begun on a new building specifically to house St. Luke's. Known as "the Lutheran Church of Times Square," this building at 308-316 West Forty-Sixth Street (just west of Ninth Avenue) was completed in 1923. At the time this postcard was printed, Albert L. Neibacher was pastor. He began his service there in 1935 and retired in 1974.

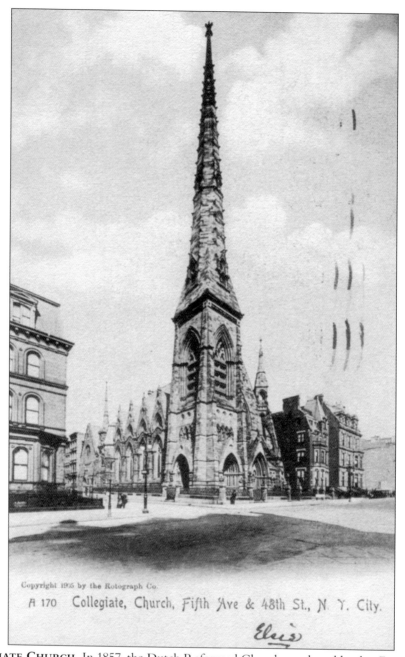

A 170 Collegiate, Church, Fifth Ave & 48th St., N. Y. City.

COLLEGIATE CHURCH. In 1857, the Dutch Reformed Church purchased land at Forty-Eighth Street and Fifth Avenue from Columbia University, and in 1869, the cornerstone was laid for a new Gothic Revival–style church at that site (just two blocks south of St. Patrick's Cathedral, which was still under construction at the time). The structure was designed by Wheeler Smith. Completed in 1872, the most prominent feature of the church was its towering 265-foot-high steeple. By the time the church was completed, Fifth Avenue had been transformed from a mostly empty place to a haven for the wealthy. Theodore Roosevelt worshipped here, in what would become known as the Collegiate Church of St. Nicholas. The church closed in 1947, and the magnificent building was demolished in 1949. The land was then leased to Rockefeller Center.

ST. PATRICK'S CATHEDRAL. Located on Fifth Avenue between Fiftieth and Fifty-First Streets, St. Patrick's was one of the tallest structures in the city when built, with twin spires that rise to a height of 330 feet. St. Patrick's was designed by the highly respected architect James Renwick, who had designed Grace Church a decade earlier. The church was first proposed in 1850, and the cornerstone for the massive building was laid in 1858. The cathedral was finally finished in 1879 after delays caused by the Civil War and lack of funding.

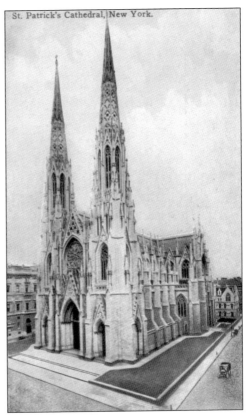

St. Patrick's Cathedral, New York.

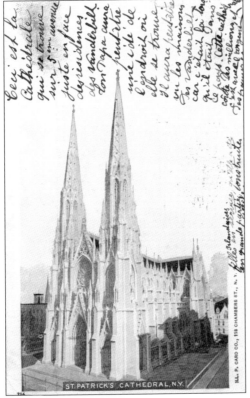

ST. PATRICK'S CATHEDRAL, N.Y.

ST. PATRICK'S CATHEDRAL CARD TO FRANCE. This c. 1898 image of the cathedral is on a postcard mailed to France. The woman who signed the card wrote this message: "This is the Cathedral that is located on 5th Avenue just across from the Vanderbilt residence. . . . this Cathedral cost millions and it is with the money of the poor Irish girls that the great majority was constructed."

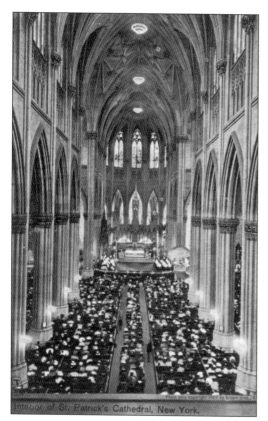

Interior of St. Patrick's Cathedral, New York.

St. Patrick's Interior. This image presents an excellent vantage point of the massive scale of St. Patrick's. The clothes of the worshippers offer a contrast to the austere gray of the soaring arches. This card was part of a Raphael Tuck & Sons (British publishers to the "their Majesties the King and Queen") series called American Cathedrals. It was printed in Saxony, Germany.

St. Patrick's Cathedral Postcard. This 1940s Mainzer card shows St. Patrick's as seen from across Fifth Avenue. As Fifth Avenue became more built-up, it was harder to find vantage points from which to capture the entire cathedral in one image.

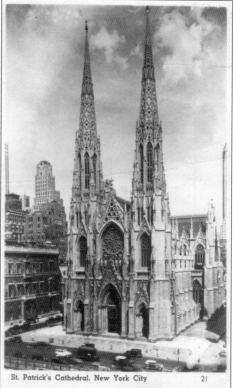

St. Patrick's Cathedral, New York City 21

ST. PATRICK'S CATHEDRAL HEAD-ON VIEW. A rare and a little bit surreal-looking head-on view of the famous Fifth Avenue attraction, this Success Postal Card Co. view features an Irving Underhill image from 1910. The image shows the 156-foot-high central gable and the highly ornamental grand portal. The card is postmarked 1914.

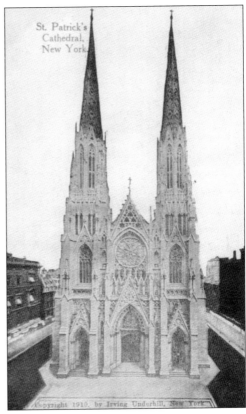

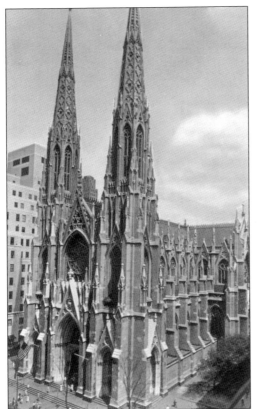

ST. PATRICK'S CATHEDRAL COLOR VIEW. In the second half of the 20th century, there were further improvements to the cathedral. During the 1950s, the installation of the upper windows was completed. In the 1970s, both the interior and exterior were restored. This Plastichrome card by Colourpicture Publishers was distributed by the Manhattan Post Card Publishing Company.

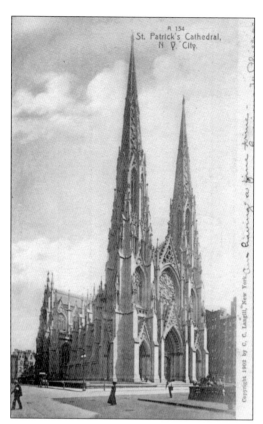

ST. PATRICK'S CATHEDRAL, 1902.
Though the streets around St. Patrick's (seen in this Rotograph Co. image from 1902) were crowded on Sunday mornings at the turn of the 20th century, on other days and other times, there was not much activity in the vicinity. This section of Fifth Avenue was still residential at the time and had yet to become the shopping and tourist attraction it is today.

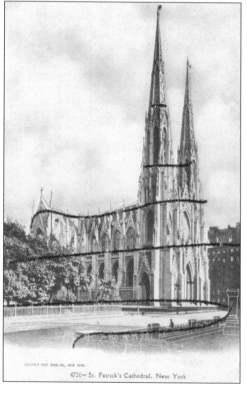

ST. PATRICK'S CATHEDRAL WITH TINSEL.
This early card has several interesting features. Firstly, the church is rather clumsily tinseled. Secondly, this view predates the building that was across the street to the north of the church; a fenced property with trees is visible. Thirdly, a Lutheran hymn written in 1865 is scrawled on the reverse: "Now the day is over, night is drawing nigh, shadows of the evening, steal across the sky. Jesus give the weary, calm and sweet repose, within thy tenderest blessing, may my eyelids close."

ST. PATRICK'S CATHEDRAL WITH TREES.
This turn-of-the-20th-century view by J.
Koehler prominently shows the trees on the
property just north of the cathedral. Note the
ornamental brick wall in the foreground, on
the west side of Fifth Avenue.

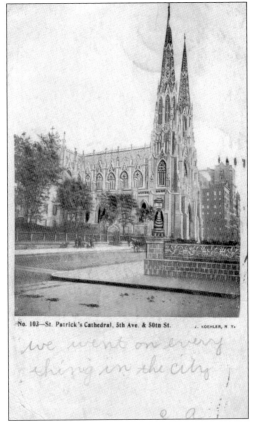

No. 103—St. Patrick's Cathedral, 5th Ave. & 50th St. J. KOEHLER, N Y.

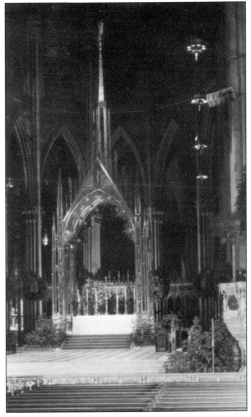

ST. PATRICK'S HIGH ALTAR. This 1956
postcard shows the high altar at St. Patrick's
Cathedral decorated for Christmas. The
high altar was consecrated on May 9, 1942,
by Archbishop Francis Spellman. This new
altar was one of several improvements that
Spellman spearheaded during the 1940s.

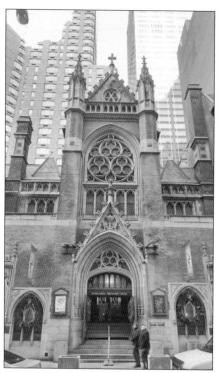

ST. MALACHY'S CHURCH. Founded in 1902, this Roman Catholic church is located on West Forty-Ninth Street between Broadway and Eighth Avenue. When this neighborhood became the city's primary theater district in the 1910s, the church became a haven for actors and tourists. In 1920, an actors' chapel was built below the main church. Among those who worshipped here were Bob Hope, Danny Thomas, Spencer Tracy, and Perry Como.

ST. BARTHOLOMEW'S CHURCH. This c. 1910 photograph shows the entrance to this Episcopal church, then located on Madison Avenue. The current iteration of the church, on Park Avenue between Fiftieth and Fifty-First Streets, was designed by Bertram Grosvenor Goodhue and completed in 1919. The portal shown in this photograph was designed by Stanford White for the 1876 version of the church as a memorial to Cornelius Vanderbilt and modeled after that of a French abbey. When the church moved, Vanderbilt's widow paid to have the portal moved to the new site, and the new building was designed around it. (Courtesy of the Library of Congress.)

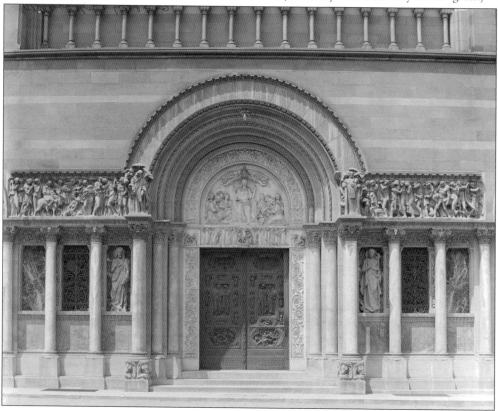

SWEDISH METHODIST CHURCH.
The congregation, founded in 1882, occupied a building at 590 Lexington Avenue (corner of Fifty-Second Street) that had previously been the Lexington Avenue Methodist Episcopal Church, built in 1846. The church later became known as the Lexington Avenue Swedish Methodist Church. The building no longer exists. This card, published by Carl Dahlen of 629 Third Avenue, is "guaranteed handcolored."

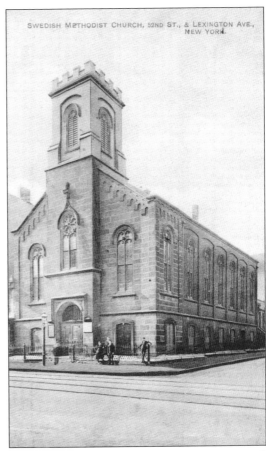

SWEDISH METHODIST CHURCH, 52ND ST., & LEXINGTON AVE., NEW YORK.

ST. THOMAS AND FIFTH AVENUE PRESBYTERIAN CHURCHES. Along late-19th-century Fifth Avenue, church spires stood out gallantly among the mansions of the wealthy. This turn-of-the-century image with a view looking north from Fifty-First Street shows two examples. At center, the massive tower of the St. Thomas Episcopal Church at Fifty-Third Street is visible. To the right of St. Thomas's is the Fifth Avenue Presbyterian Church (designed by Carl Pfeiffer), located at Fifty-Fifth Street and completed in 1875.

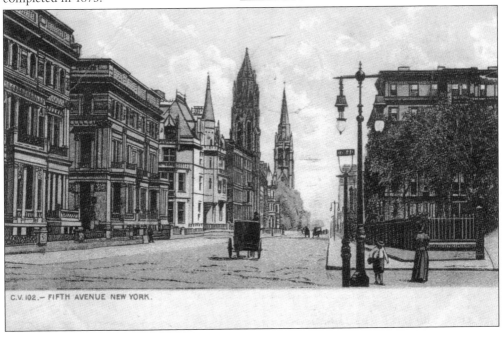

C.V. 102.— FIFTH AVENUE NEW YORK.

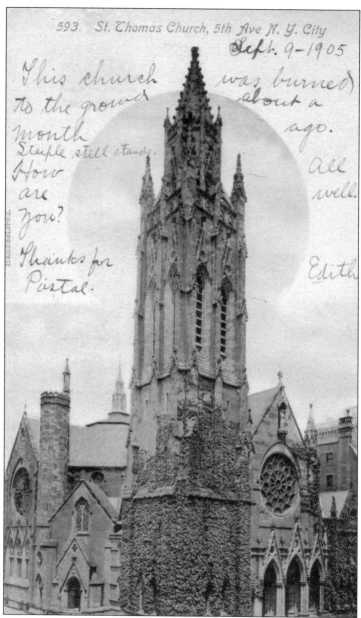

593. St. Thomas Church, 5th Ave N. Y. City

Sept. 9-1905

This church was burned to the ground about a month ago. Steeple still stands. How are you?

All well.

Thanks for Postal.

Edith

ST. THOMAS CHURCH THEN. The first St. Thomas Church was built at Broadway and Houston Street during the 1820s. The parish relocated to Fifth Avenue and Fifty-Third Street in 1870. This image shows the second St. Thomas Church (designed by Richard Upjohn), which burned down in 1905; as described by the sender a month after the fire, the "steeple still stands." Just days after the fire, it was determined a new church would be built upon the same site. At first the intent was to reuse the tower, but eventually, it was decided to erect an entirely new building. A temporary structure with a seating capacity of 1,200 was constructed within the walls of the burnt building for about $25,000; it was dismantled when the walls and roof of the new church were finished. Only a few things were salvaged from the church, including the bronze cross from the altar and the bronze bust of the Reverend William Morgan. Among the artworks destroyed was the bronze bas-relief reredos by Augustus Saint-Gaudens.

ST. THOMAS CHURCH NOW. The cornerstone for the third St. Thomas Church was not laid until November 1911, five years after the devastating fire that had destroyed the second one. Work on the French High Gothic–style structure, designed by Bertram Grosvenor Goodhue and Ralph Adams Cram, was completed in just under two years, and the first services in the new church were held in October 1913.

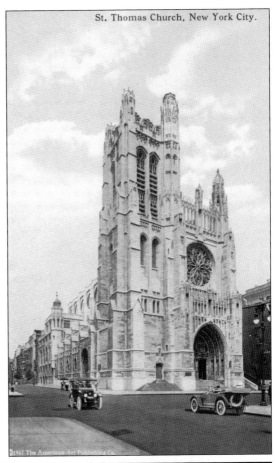

St. Thomas Church, New York City.

©1917 The American Art Publishing Co.

ST. THOMAS CHURCH TAPESTRY. The Gould Memorial Tapestry was woven specifically for the space behind the high altar. It was made in 1956 by the Edinburgh Tapestry Company in Corstorphine, Scotland, and designed by Canon West of the Cathedral of St. John the Divine.

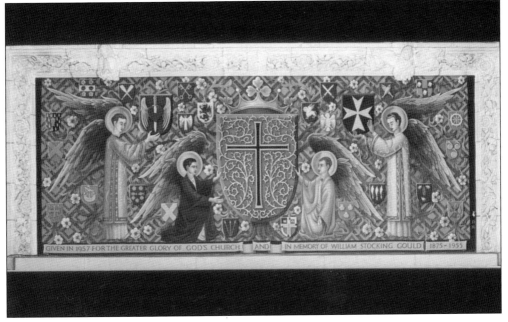

GIVEN IN 1957 FOR THE GREATER GLORY OF GOD'S CHURCH AND IN MEMORY OF WILLIAM STOCKING GOULD 1875–1955

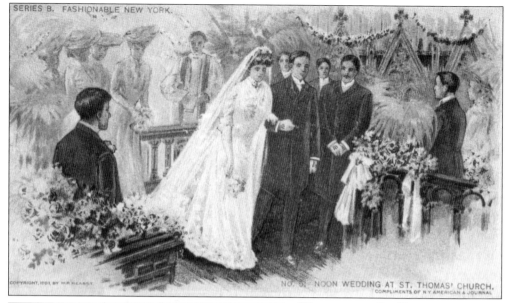

COPYRIGHT, 1903 BY W.R.HEARST. NO. 5. NOON WEDDING AT ST. THOMAS' CHURCH.
COMPLIMENTS OF N.Y. AMERICAN & JOURNAL

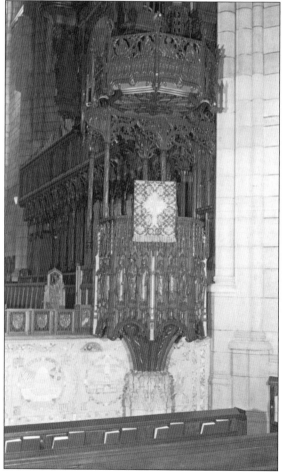

WEDDING AT ST. THOMAS CHURCH. A wedding at either of the two big Fifth Avenue churches—St. Patrick's or St. Thomas—was a fancy affair. This postcard was part of a series called Fashionable New York and was given compliments of the William Randolph Hearst publication *New York American and Journal* in 1903.

ST. THOMAS PULPIT. The elaborately detailed oak pulpit includes carved figures of 19 famous preachers from places such as England, France, Nova Scotia, Kentucky, and New York, with the name inscribed under each one. The two New York preachers represented are Henry C. Potter, Bishop of New York, and William R. Huntington, Rector of Grace Church. The figures on the frieze above the sounding board represent seven prophets of the Old Testament— Isaiah, Jeremiah, Ezekiel, Daniel, Micah, Zechariah, and Amos.

ST. THOMAS CHURCH INTERIOR. The c. 1960 Eston Color Reproductions postcard at right and the 1972 Dexter postcard below show the altar of the church, featuring an impressive sculpted stone reredos that is one of the largest in the world. (It replaced the stunning reredos of the second church, which consisted of four polychromed panels designed by the famed artist Augustus Saint-Gaudens.) It is 43 feet wide and 80 feet high and contains over 80 figures designed by Lee Lawrie and carved in Dunnville sandstone from Wisconsin. The church is built entirely of stone, following construction techniques over 1,000 years old. The nave is 95 feet in height. The church's cost was $1,171,906.

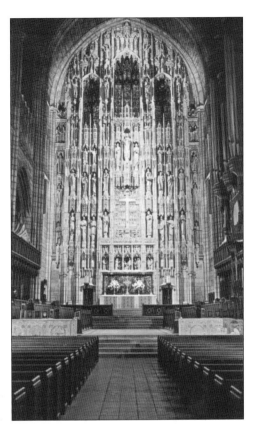

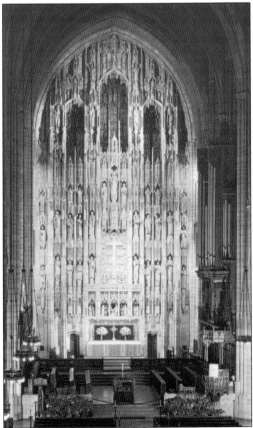

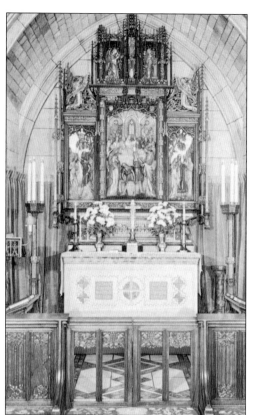

ST. THOMAS CHURCH CHANTRY ALTAR. The chantry chapel altar reredos is made of carved, gilded, and polychromed wood. The main panels represent, from left to right, the baptism of Jesus by John the Baptist, the marriage at Cana, and the raising of Lazarus from the dead.

FIFTH AVENUE PRESBYTERIAN CHURCH. This c. 1930s Albertype postcard of the Hotel St. Regis shows the steeple of the Fifth Avenue Presbyterian Church in the foreground. The congregation was founded in 1808 on Cedar Street, moved to Duane Street in 1834, to Fifth Avenue and Nineteenth Street in 1852, and then Fifth Avenue and Fifty-Fifth Street in 1875—its present location. Among the original members of the church were former secretary of the treasury Oliver Wolcott Jr. and former New York City mayor Richard Varick.

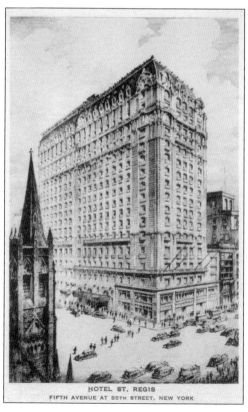

HOTEL ST. REGIS
FIFTH AVENUE AT 55TH STREET, NEW YORK

FIFTH AVENUE ON SUNDAY. Both this Illustrated Post Card Co. image dating to about 1905 (seen at right) and the American Art Publishing Co. image from about 10 years later (below) show a crowded Fifth Avenue in the vicinity of St. Patrick's Cathedral on a Sunday. According to the caption below, "Many of the prominent churches are located here and on Sunday morning the Avenue is crowded with worshippers going to church." The image below demonstrates the chaotic nature of New York City traffic in the very early years of the automobile, before traffic lights were installed beginning in 1920. In 1912 alone, 210 people in the city were killed in automobile accidents in the city—95 percent of them pedestrians.

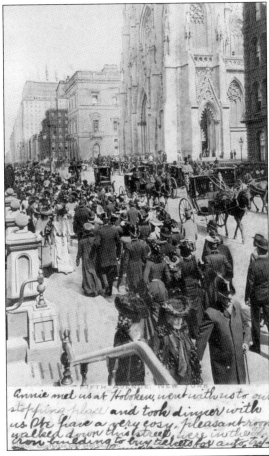

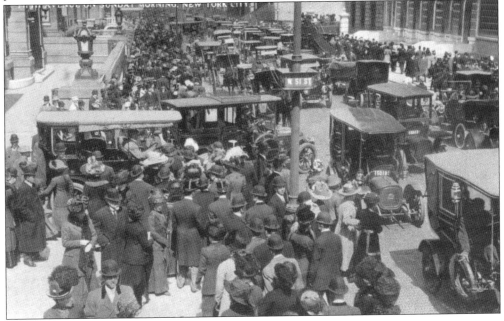

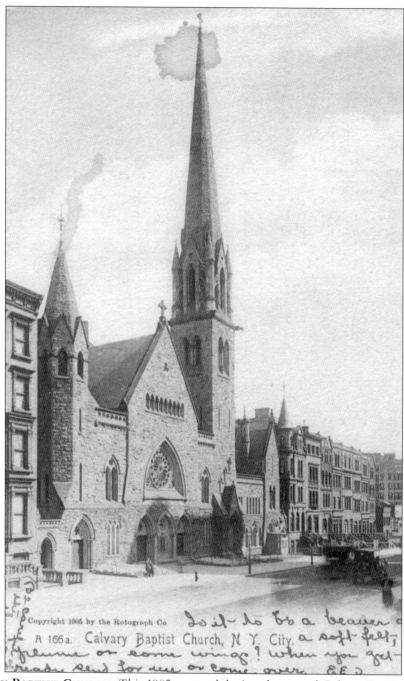

Copyright 1905 by the Rotograph Co *Is it to be a beaver*

A 166a. Calvary Baptist Church, N. Y. City. *a soft felt;*
plume or some wings? when you get
ready send for me or come over. EE

CALVARY BAPTIST CHURCH. This 1905 postcard depicts the second Calvary Baptist Church. The church was founded in 1847, and the first building was constructed on West Twenty-Third Street. The congregation moved to a new, larger building at 123 West Fifty-Seventh Street in 1884. In 1929, the building was demolished, and the church relocated to within a 16-story hotel at the same site. Located across the street from Carnegie Hall, the Salisbury Hotel, which has 197 rooms, shares its building with the Calvary Baptist Church. The most distinctive feature of the new building visible from street level is the church's large Gothic portal.

MANHATTAN BAPTIST CHURCH. Constructed in the 1920s, the church occupied this location at 31 West Fifty-Seventh Street for around 40 years. It then hosted Media Sound Studios, and because of its excellent acoustics, the likes of Billy Joel, John Lennon, Frank Sinatra, and the Rolling Stones recorded music there. In the 1990s, it became a famous club, Le Bar Bat, and most recently, it is a catering hall hosting a variety of events.

CHURCH OF ST. PAUL THE APOSTLE. The cornerstone for this 13th-century-Gothic–style church was laid in 1873, and the building, located on Fifty-Ninth Street at Columbus Avenue, was completed in 1885. In 1892, it was said to be the second-largest church building in the country, at 284 feet long and 132 feet wide with a seating capacity of 5,000.

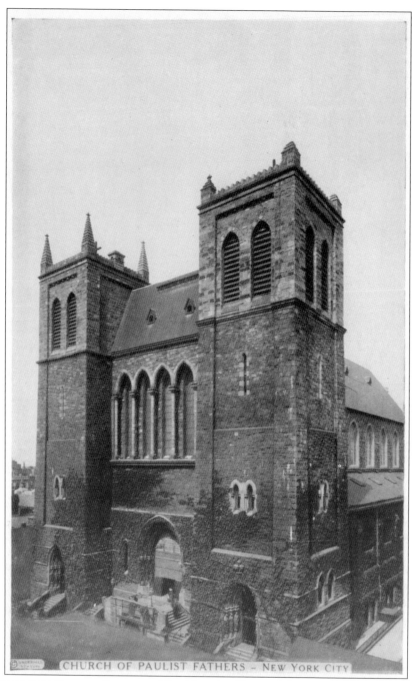

CHURCH OF PAULIST FATHERS - NEW YORK CITY

CHURCH OF THE PAULIST FATHERS. The Church of St. Paul the Apostle has also been known as the Church of the Paulist Fathers. The Paulist Fathers, founded 1858, was the first men's religious order established in the United States. The church interior features the artistic works of such well-known artists as John LaFarge, Augustus Saint-Gaudens, Lumen Winter, Stanford White, and William Laurel Harris. The ceiling was painted blue and studded with stars and constellations representing their positions on January 25, 1885, the festival of the conversion of St. Paul.

94

Three

UPPER EAST SIDE
AND EAST HARLEM

The construction of Central Park in the late 1850s and early 1860s created not only the northern boundary for Midtown Manhattan but also a very distinct separation between the Upper East Side and the Upper West Side.

As Manhattan's growth spread further north, the Upper East Side saw the construction of a wide variety of residences—everything from mansions, to tenements, to apartment buildings. An influx of immigrants, first European and then others, began to settle mainly in the areas east of Third Avenue, while the wealthy built brownstones close to Fifth Avenue and Central Park.

A variety of churches were built during the late 19th and early 20th centuries to serve this ethnically diverse and burgeoning population.

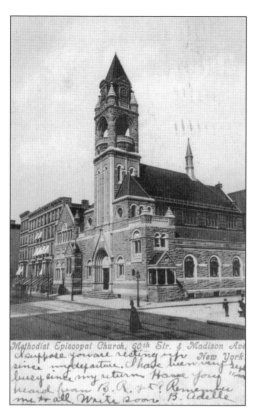

Methodist Episcopal Church, 60th Str. & Madison Ave
I suppose you are resting up in New York since my departure. I have been very busy since my return. Have you heard from B. R. yet? Remember me to all. Write soon. B. Adelle

MADISON AVENUE METHODIST EPISCOPAL CHURCH. This church (today known as Christ Church, United Methodist) was organized in 1881, and its cornerstone was laid in 1882. The Romanesque-style stone building, seen on this American News Co. postcard, was completed in 1883 on East Sixtieth Street, with a 175-foot-high bell tower. By the 1920s, the church was becoming too small, so it was decided to construct a new, larger building on a site down the street.

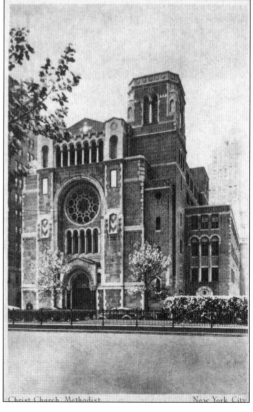

Christ Church Methodist New York City

CHRIST CHURCH, METHODIST. This church was initially organized in 1881 as the Madison Avenue Methodist Episcopal Church. Located at Park Avenue and Sixtieth Street, Christ Church is a fine example of Byzantine architecture. Completed in 1933, the church is shown in this 1930s postcard.

PARK AVENUE BAPTIST CHURCH. Located at Park Avenue and Sixty-Fourth Street, the church was known for 50 years as the Fifth Avenue Baptist Church for its address just off of Fifth Avenue at Forty-Sixth Street. In 1922, the church moved to 593 Park Avenue. That Gothic Revival building, shown here, included three auditoriums in addition to the main church. The congregation moved to the Riverside Church at 122nd Street upon its completion in 1930. The Lumitone postcard to the right dates to around 1927, and the photograph below dates to 1931. The structure, minus the carillon, which the Baptists took with them to Riverside Church, is now home to the Central Presbyterian Church.

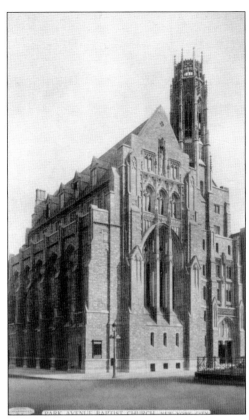

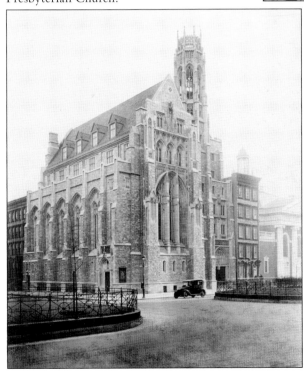

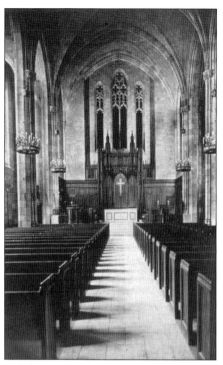

CENTRAL PRESBYTERIAN CHURCH. Seen in an early-1930s postcard, this church was founded in 1821. It shifted locations several times before finding a home at its present site, at the corner of Park Avenue and Sixty-Fourth Street, in 1929. The building had originally been constructed as a home for the Park Avenue Baptist Church, funded in part by John D. Rockefeller—but large crowds caused Rockefeller to fund a new church, Riverside Church, in Morningside Heights.

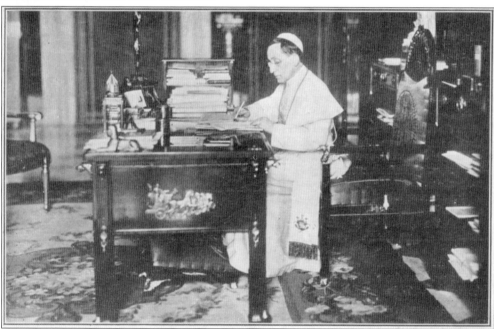

CHRISTMAS PLEA FOR DONATIONS. This postcard shows Pope Pius XII, dating it to between 1939 and 1958. The reverse features a request for donations to the Catholic Church: "Does not the idea of a personal Christmas gift to the Holy Father appeal to your filial Catholic heart and your American sense of generosity?" Donations were asked to be sent to the Provincial at 869 Lexington Avenue (Sixty-Fifth Street), the headquarters of the Eastern United States Province of the Dominican Order.

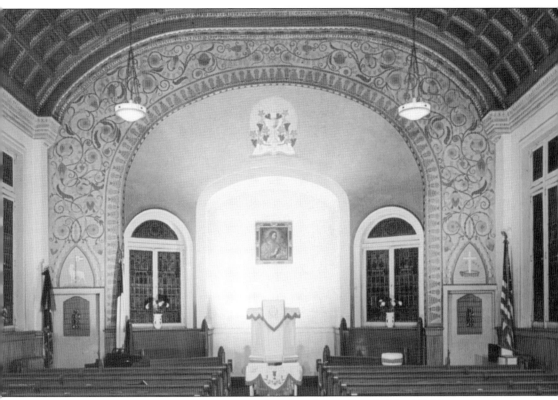

FIRST HUNGARIAN REFORMED CHURCH. This church was founded in 1895 by a growing population of Hungarian immigrants and was first housed in a building on East Seventh Street. The current structure is located at 334 East Sixty-Ninth Street. The building's move reflected the move of Hungarians uptown to the area near Yorkville, known as Little Hungary (though the church's location is actually a few blocks south of the center of Little Hungary). The current church was designed by the Hungarian architect Emery Roth in 1915, utilizing Viennese and Hungarian styles.

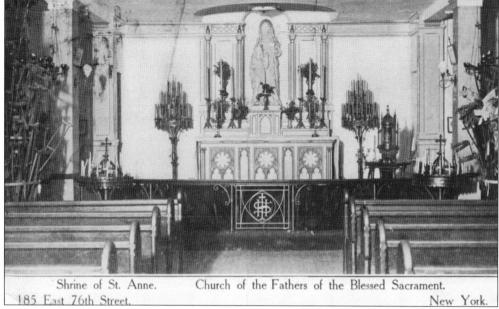

Shrine of St. Anne. Church of the Fathers of the Blessed Sacrament.
185 East 76th Street. New York.

ST. JEAN BAPTISTE CHURCH. Founded by the Congregation of the Blessed Sacrament (an order that originated in Paris in 1856) in 1882, this Roman Catholic church was built to cater to the French Canadian Catholics in the city. Located in the Lenox Hill section of Manhattan, the church was originally at 159 East Seventy-Sixth Street (Lexington Avenue), in a building that was completed in 1885. In 1892, St. Jean Baptiste was presented with a relic of St. Anne (mother of Mary and grandmother of Jesus) from Sainte-Anne-de-Beaupré in Quebec. The Shrine of St. Anne is depicted in the postcard above. Due to overcrowding and with funding from a wealthy parishioner, a new church was built in 1913 at 184 East Seventy-Sixth Street. The image above, postmarked in 1909 and which predates the new building, incorrectly reads "185 East 76th Street." The image below shows the main altar in the crypt. The building is a New York City Landmark and is in the National Register of Historic Places.

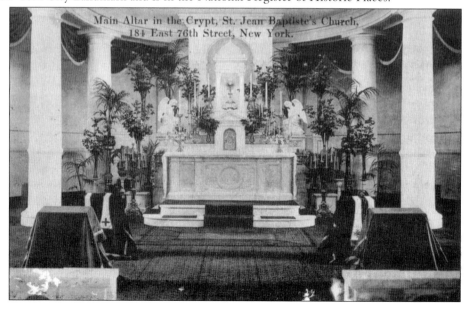

Main Altar in the Crypt, St. Jean Baptiste's Church, 184 East 76th Street, New York.

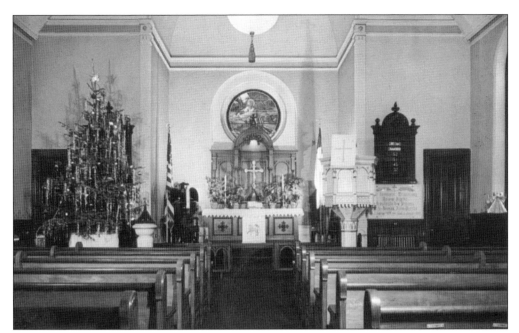

ZION ST. MARKS CHURCH. This postcard shows the interior of the Evangelical Lutheran church located at 339 East Eighty-Fourth Street. This church was founded in 1892 as the Zion Church, serving a primarily German-speaking congregation. It merged with St. Marks Church on the Lower East Side after many of the St. Marks parishioners died on the tragic PS *General Slocum* steamship disaster in 1904, and many of the friends and relatives of those who perished moved up to Yorkville, near the Zion Church.

PARK AVENUE CHRISTIAN CHURCH. The Disciples of Christ was formed in 1810 when nine members of the Ebenezer Baptist Church formed a new group. According to the information in the caption of this Albertype postcard, the Disciples of Christ was the largest religious body originating in the United States (numbering 1.8 million people) when this postcard was printed sometime in the 1950s. The church is located at 1010 Park Avenue (Eighty-Fifth Street). Originally built as the South Dutch Reformed Church in 1911, the building was purchased by the congregation in 1945.

Park Avenue Christian Church, Disciples of Christ
Established 1810
Park Avenue at East 85th Street
New York 28, New York

Dear Martha:— do you
recognize this church I
am having a fine time —
fair is lovely. Love to him
Mal.

GERMAN EV. LUTH. IMMANUEL'S CHURCH
LEXINGTON AVE. AND EIGHTY-EIGHTH ST., NEW YORK

GERMAN EVANGELICAL LUTHERAN IMMANUEL'S CHURCH. Currently known as Immanuel Lutheran Church, this building, located at 122 East Eighty-Eighth Street (Lexington Avenue) was built in 1886. The congregation was formed in 1863. The three bells in the 200-foot-high tower were a gift from the empress of Germany in the late 19th century.

THE ORIGINAL CHURCH OF THE HEAVENLY REST. This parish originated in services held in Rutgers Female College in 1865. The first iteration of this Episcopal church was located at 551 Fifth Avenue, at Forty-Fifth Street. The name was chosen as a memorial to the Civil War dead. A soup kitchen was opened in 1890 to feed the hungry.

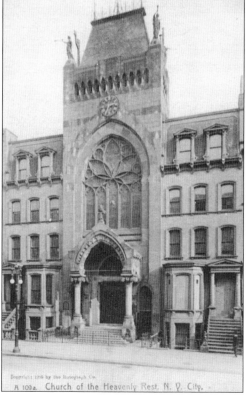

A 109a. Church of the Heavenly Rest, N. Y. City.

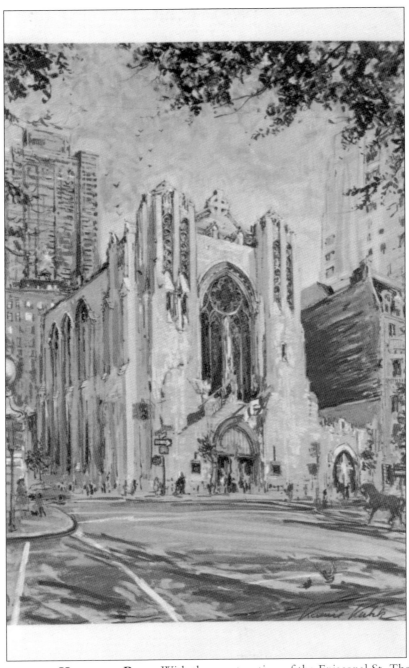

CHURCH OF THE HEAVENLY REST. With the construction of the Episcopal St. Thomas and St. Bartholomew Churches a few blocks away, a decision was made during the 1920s to move the Church of the Heavenly Rest uptown to Fifth Avenue and Ninetieth Street, to land sold to them by the widow of Andrew Carnegie. Louise Whitfield Carnegie lived across the street from the site in her mansion, which is now the Cooper-Hewitt Museum. Heavenly Rest merged with nearby Church of the Beloved Disciple on Eighty-Ninth Street. This fine example of Gothic Revival architecture (tinged with Art Deco) was completed in 1929. A fire in 1993 caused severe damage, but much was repaired within a year. The church receives 15,000 visitors per year.

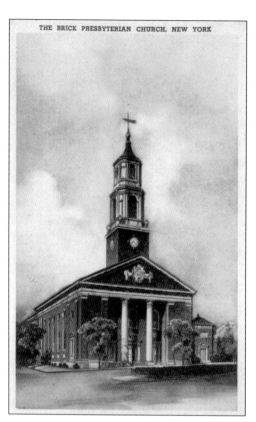

THE BRICK PRESBYTERIAN CHURCH, NEW YORK

BRICK PRESBYTERIAN CHURCH. This church was founded in 1767 at Beekman Street in Lower Manhattan (where Pace University currently is located) as an expansion of the First Presbyterian Church. During the Revolution, the church was used by the British as a hospital. In 1858, the church moved to Thirty-Seventh Street and Fifth Avenue. On November 28, 1938, the cornerstone for a third iteration of the church was laid at Ninety-First Street and Park Avenue. The dedication of the new church occurred on April 4, 1940. This postcard was postmarked 1943.

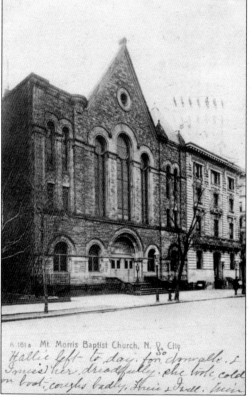

A-161a Mt. Morris Baptist Church, N. Y. City

MOUNT MORRIS BAPTIST CHURCH. The first Mount Morris building on this site was a small chapel built in 1854. It was replaced with the structure seen in this pre-1907 card (designed by Henry F. Kilburn) in 1888. The congregation left in about 1934. Located at 2050 Fifth Avenue, between 126th and 127th streets, the building was later occupied by a different congregation and is now called the Mount Moriah Baptist Church.

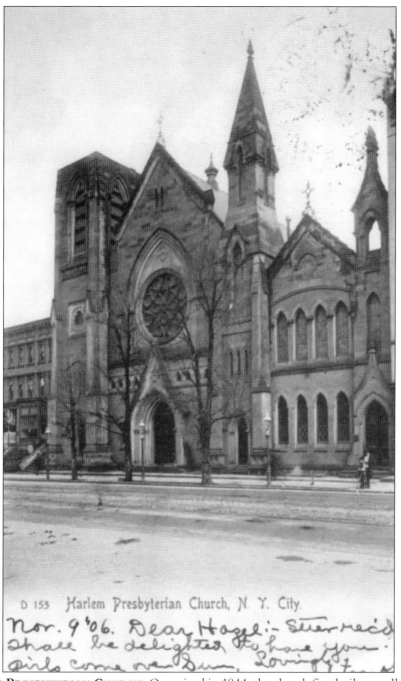

D 153 Harlem Presbyterian Church, N. Y. City.

Nov. 9 '06. Dear Hazel:- *letter received* *I shall be delighted to have you girls come over Sun. Lovingly*

HARLEM PRESBYTERIAN CHURCH. Organized in 1844, the church first built a small wooden structure located on 127th Street, east of Third Avenue. In 1873, it moved to a new building at 45 East 125th Street at Madison Avenue, shown on this postcard. The cornerstone of the third church, a Romanesque-style building designed by Thomas H. Poole and featuring a copper dome, was laid in 1905. In 1915, the congregation moved to 15 Mount Morris Park West. In 1942, the church merged with the Rutgers Presbyterian Church. The third church is now known as the Mount Morris Ascension Presbyterian Church.

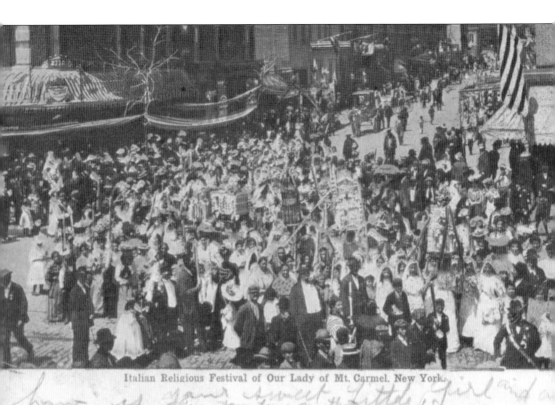
Italian Religious Festival of Our Lady of Mt. Carmel, New York.

FEAST OF OUR LADY OF MOUNT CARMEL. This popular feast is held every July on 115th Street, near the site of the Church of Our Lady of Mount Carmel, which was built at 449 East 115th Street in what was then Italian Harlem. The first feast was held in 1881, and the first chapel was in use in a rented apartment on 111th Street in 1884. Funds were raised, and the Romanesque-style church on East 115th Street was completed in 1889. In those early days, the church was shared with Irish Catholics, who were also neighborhood residents. This postcard shows the feast around 1908. The church is known for its crowned statue of Mary, which came from Italy in the 1880s. The coronation, authorized by Pope Leo XIII, took place in July 1904.

Four

UPPER WEST SIDE, MORNINGSIDE HEIGHTS, AND HARLEM

While the largely residential Upper West Side's attractions range from Lincoln Center to the American Museum of Natural History to Columbia University, two of the most visited landmarks in the area are churches: the Cathedral of St. John the Divine and the Riverside Church. Both are incredibly massive Gothic-style masterpieces and are among the tallest churches in the world. Both are also scenically situated, with St. John's perched on the west side of Morningside Park, and Riverside offering magnificent views of Riverside Park, Grant's Tomb, and the Hudson River.

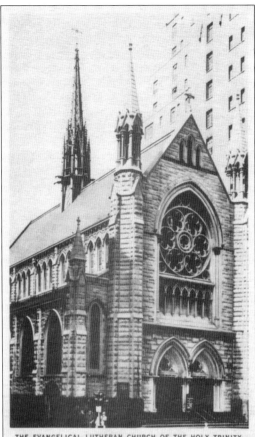

THE EVANGELICAL LUTHERAN CHURCH OF THE HOLY TRINITY

EVANGELICAL LUTHERAN CHURCH OF THE HOLY TRINITY. Founded in 1868, the church was first located at 47 West Twenty-First Street. In 1902, the church purchased land at Central Park West and Sixty-Fifth Street. Construction on the new church was made possible by sale of the Twenty-First Street building. The new building was consecrated in 1904. The postcard's caption indicates that "many tourists consider it a MUST among New York places to visit."

EVANGELICAL LUTHERAN CHURCH OF THE HOLY TRINITY AT CHRISTMAS. This c. 1953 postcard's caption reads, "A towering Christmas tree, candlelight Carol Services, Midnight Christmas Eve Devotions, Christmas Day Celebrations of Holy communion are features of the Feast of the Nativity at Holy Trinity Lutheran Church. Visiting worshippers and members find joy in this church's rich liturgy, Christmas music and Christ-centered preaching."

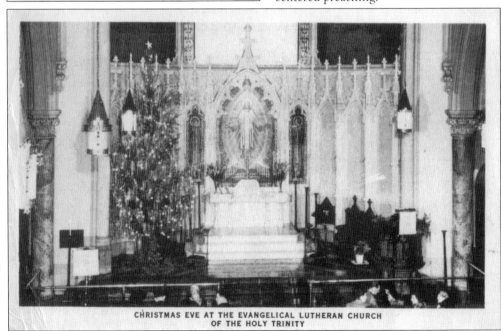

CHRISTMAS EVE AT THE EVANGELICAL LUTHERAN CHURCH OF THE HOLY TRINITY

EVANGELICAL LUTHERAN CHURCH OF THE HOLY TRINITY EASTER. This postcard shows the Passiontide Cross, made from the church's Christmas tree, which, according to the back of this mid-20th-century postcard, "bursts into radiant floral beauty on the Day of Resurrection, in celebration of the Victory News at Eastertime—Christ is Risen!"

EASTER DAY AT THE EVANGELICAL LUTHERAN CHURCH OF THE HOLY TRINITY

SECOND CHURCH OF CHRIST, SCIENTIST. This Beaux-Arts cube-shaped masterpiece was completed in 1901, not long before this postcard was published. Located at 10 West Sixty-Eighth Street, it is now known as the First Church of Christ, Scientist, after that church combined with this one in 2003. Part of what the sender of this card wrote on the side reads, "Have only been able to get pictures of three of the C.S. churches."

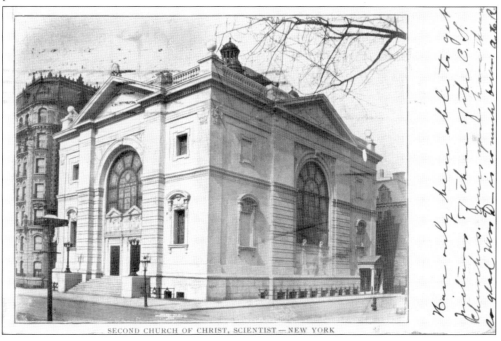

SECOND CHURCH OF CHRIST, SCIENTIST — NEW YORK

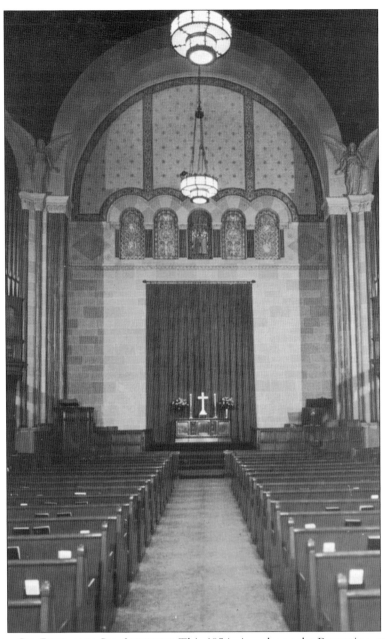

CHURCH OF ST. PAUL AND ST. ANDREW. This 1954 view shows the Byzantine-style chancel of this Methodist church, located on West End Avenue at Eighty-Sixth Street. The building on this postcard, with its lighthouse-shaped tower, was erected in 1897 as St. Paul's Methodist Church. St. Paul's had been founded in 1834. It was designed by Robert H. Robertson and cost $343,673 to build. At its dedication in 1897, there were only 67 members in the congregation. The name of the church reflects the merger in 1937 of St. Paul's with St. Andrew's, which had been founded in 1865 on West Seventy-Sixth Street. A major rehabilitation took place in 1968, but the congregation voted to demolish the building in 1979. Designation as a city landmark stopped that from happening, despite the church's subsequent petition to the US Supreme Court in protest of the constitutionality of houses of worship becoming landmarks.

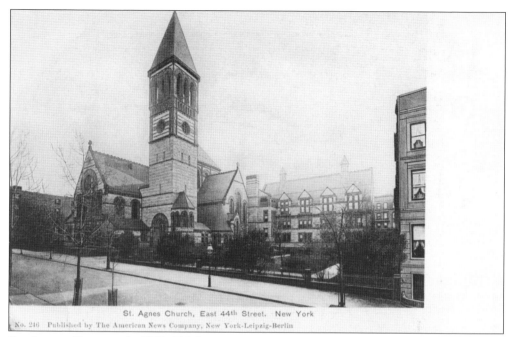

St. Agnes Church, East 44th Street. New York

No. 246 Published by The American News Company, New York-Leipzig-Berlin

ST. AGNES CHAPEL. In 1890, Trinity Church began construction on its fourth chapel, located at Ninety-Second Street and Columbus Avenue, west of Central Park. A crowd of 1,000 people watched as the cornerstone was laid with a silver trowel and a boxwood mallet with a carved ivory handle. The stone bell tower of this William Appleton Potter design rose to an impressive height of 185 feet. The cruciform Romanesque Revival chapel, which cost $800,000 to build, could seat 1,200 people. Seen here in two American News Company postcards (above, produced in 1900, and to the right, around 1908), the building was demolished in 1944 after the property was sold to the neighboring Trinity School. The card above incorrectly states that the church was located on East Forty-Fourth Street.

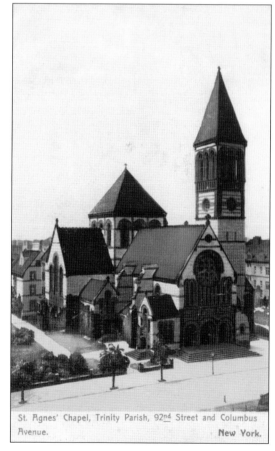

St. Agnes' Chapel, Trinity Parish, 92nd Street and Columbus Avenue. New York.

111

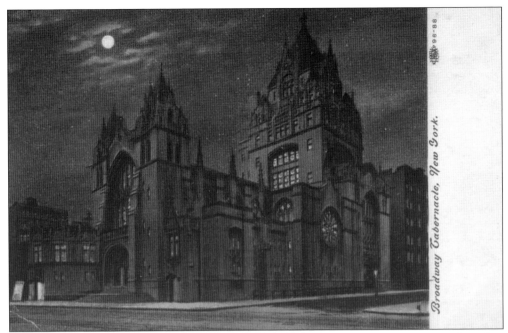

BROADWAY TABERNACLE CHURCH. The congregation was organized in 1831, and its first building was on Broadway in Lower Manhattan, between Worth Street and Catherine Lane. In 1857, the church moved to Sixth Avenue and Thirty-Fourth Street. The church shown in these two images was built on Broadway at Ninety-Third Street in 1905. The structure is now known as Broadway United Church of Christ. The night-view postcard above was published by the Illustrated Post Card Company and dates to about 1910. The view below is a Detroit Publishing Company image, also from around 1910. In 1969, the Broadway Tabernacle left this building and has shared space with several other churches since then.

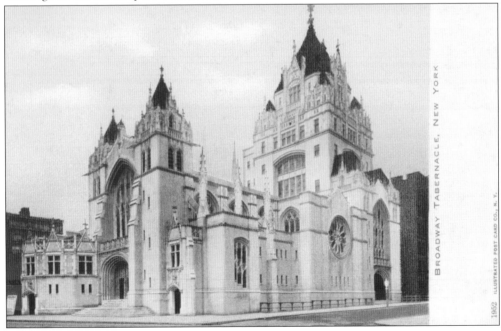

FIRST CHURCH OF CHRIST, SCIENTIST. The Church of Christ, Scientist was founded in 1879 by Mary Baker Eddy. First Church of Christ, Scientist in New York City was organized by Augusta Emma Stetson in 1887 and incorporated in 1888. The first location for this church was at 139 West Forty-Eighth Street, in an altered version of what was originally the All Souls Episcopal Church, from 1896 to 1903. The congregation then had its own church constructed on Central Park West at Ninety-Sixth Street in 1903. The building now serves as Crenshaw Christian Center East. In 2004, First Church and Second Church merged and became known as First Church of Christ, Scientist. The building is located at Sixty-Eighth Street and Central Park West (see page 109). (Courtesy of the Library of Congress.)

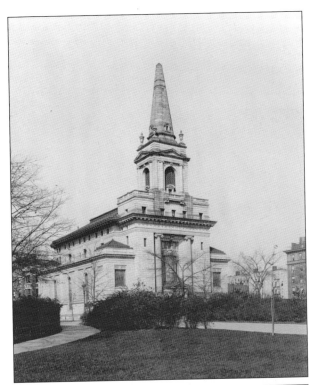

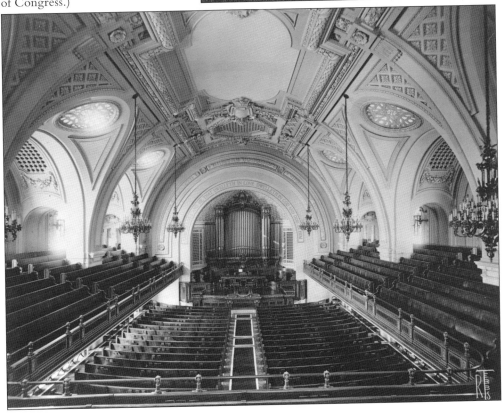

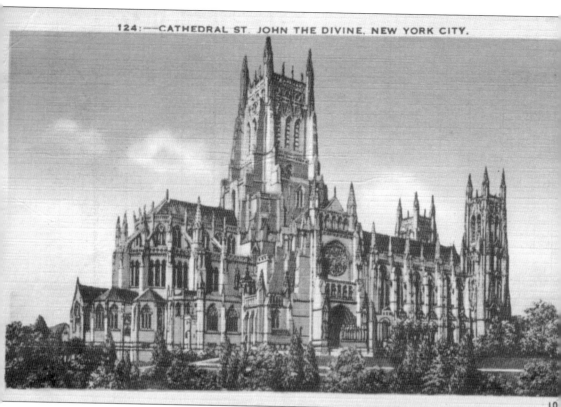

CATHEDRAL OF ST. JOHN THE DIVINE. The idea for an Episcopal cathedral in New York City dates back to 1828, when Bishop John Henry Hobart discussed the concept with Mayor Philip Hone. Funds were raised for the cathedral beginning in 1887, and a 13-acre site was purchased. Work on this monumental cathedral, located at Amsterdam Avenue between 111th and 113th Streets, was begun on St. John's Day (December 27) in 1892. Construction progressed slowly on what is one of the largest places of worship in the world. By 1911, it was only a third complete. Even to this day, impressive though it is in its current state, the cathedral is still not completely finished as originally planned. Seen in this linen Manhattan Post Card Publishing Company Image, the building is 445 feet high and is visible from 25 miles away. J.P. Morgan contributed $500,000 to the construction effort.

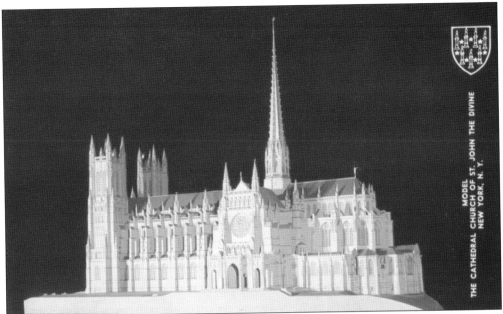

MODEL OF CATHEDRAL OF ST. JOHN THE DIVINE. The fully realized cathedral would look like what is depicted in the model on this Colorgraph by Harry H. Baumann postcard. The caption reads: "When finished it will be the largest Gothic cathedral in the world. Its length is 601 feet, the width at the crossing will be 330 feet, the height of the Central Fleche will be about 452 feet."

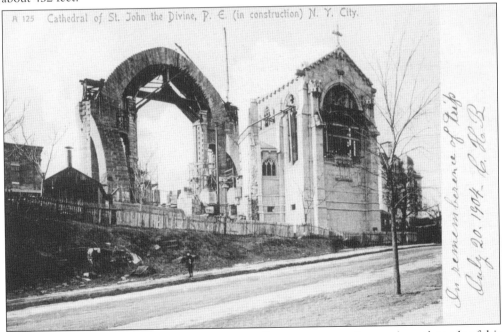

A 125 Cathedral of St. John the Divine, P. E. (in construction) N. Y. City.

CATHEDRAL OF ST. JOHN THE DIVINE UNDER CONSTRUCTION. So grand was the scale of this building that even in the early stages of construction it was deemed worthy of a postcard. This image dates to around 1904 and appears on a Rotograph Co. postcard. The cornerstone was laid in 1892, and the first services in the cathedral were held in 1899 in a chapel of the crypt.

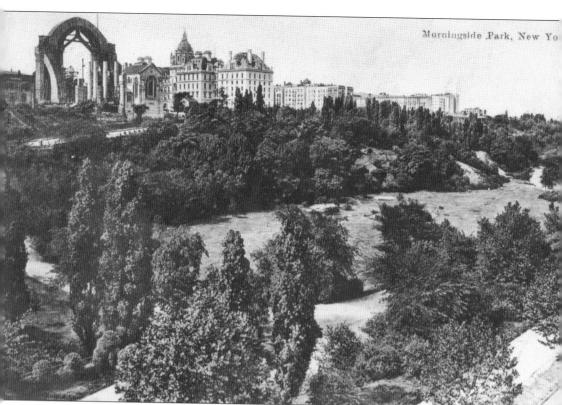

MORNINGSIDE PARK. The Cathedral of St. John the Divine can be seen in the background of this German-made postcard of Morningside Park, in its early stages of construction. Across the street from the cathedral work in progress is St. Luke's Hospital. The idea for the 13-block-long Morningside Park was first conceived in 1867. The famous landscape architects Frederick Law Olmsted and Calvert Vaux, who had designed Central Park, submitted plans for Morningside Park in 1873, but those plans were rejected by the Board of Commissioners for Public Parks and then later reworked by an architect named Jacob Wrey Mould. Construction began in 1883, but Mould died in 1886, and in 1887, Olmsted and Vaux were retained once again, this time to design improvements to the park. The work on the park was completed in 1895, just a few years after work began on the Cathedral of St. John the Divine.

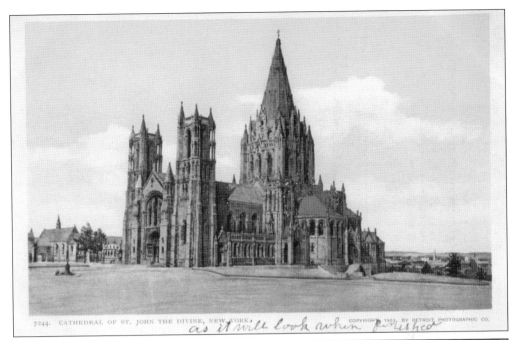

7244. CATHEDRAL OF ST. JOHN THE DIVINE, NEW YORK. *as it will look when finished* COPYRIGHT 1903, BY DETROIT PHOTOGRAPHIC CO.

CATHEDRAL OF ST. JOHN THE DIVINE ORIGINAL DESIGN. The cathedral today looks very different from its original design, by Heins and LaFarge in 1890. This 1903 Detroit Publishing Co. postcard, and others of that era, depicts what the completed church would look like based on the original design.

CHURCH OF ST. JOHN THE DIVINE BAPTISTRY. Completed in 1928, the baptistry is Gothic in style and features a marble font designed by Boston artist Albert Atkins. The baptistry was a gift of the Stuyvesant family and includes a representation of the family's most famous member, Peter Stuyvesant.

117

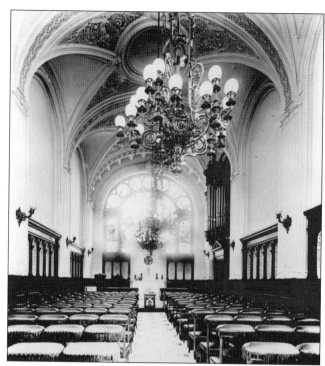

CHAPEL IN ST. LUKE'S HOSPITAL. This Episcopal hospital was built just north of the Church of St. John the Divine. Designed by Ernest Flagg, the hospital opened in 1896. Muhlenberg Chapel is in a separate wing and modeled after 17th-century French chapels. The large stained-glass window behind the altar was designed by an English artist named Henry Holiday. This photograph dates to 1899. (Courtesy of the Library of Congress.)

BROADWAY PRESBYTERIAN CHURCH. Founded in 1822 in Greenwich Village and soon known as the Bleecker Street Presbyterian Church, the congregation moved to Fourth Avenue and Twenty-Second Street in the 1850s (and became Fourth Avenue Presbyterian). That building was demolished in 1910, and the church then moved north to its current location (and name) at Broadway and 114th Street in 1912. The architect was Louis E. Jallade. A rather odd close-up perspective of the exterior of the church is seen on this real-photo postcard.

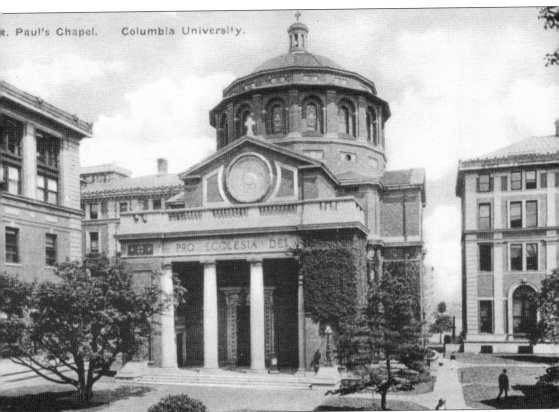

ST. PAUL'S CHAPEL. Columbia University, the fifth-oldest institution of higher learning in the United States, was established as King's College in 1754 and held its first classes at a schoolhouse adjoining Trinity Church. There were eight students in the first class. Classes were suspended during the American Revolution, and in 1784, the school reopened as Columbia. It moved from Park Place to Madison Avenue and Forty-Ninth Street in 1857. Under its president Seth Low, Columbia moved uptown to a more spacious campus. A few years after the school moved to 116-120th Streets in Morningside Heights in 1897, the construction of a chapel was financed through a pair of philanthropist sisters, whose gift was conditional upon their architect nephew, I.N. Phelps Stokes, designing the building. Seen in an Albertype postcard, the chapel was completed in 1907.

CORPUS CHRISTI CHURCH. The Albertype postcard above presents an interesting, partly obstructed view of the high altar of Corpus Christi Church, a Roman Catholic church located at 533 West 121st Street in Morningside Heights. The parish was founded in 1906. Construction on the church was begun in November of that year and completed just seven months later. A new church building at the same location was constructed in 1935. The Albertype card below shows the Lady Chapel in the new building. The famous monk and writer Thomas Merton was baptized into the Catholic Church at Corpus Christi a few months after having wandered into mass there on Sunday in 1938 while he was a graduate student at Columbia University.

RIVERSIDE CHURCH. Seen in a c. 1959 view, the Riverside Church (Baptist) was built in the French Gothic style. Located at Riverside Drive and 123rd Street near Grant's Tomb and Columbia University, the church is 392 feet high (making it one of the tallest churches in the country) and seats up to 2,500 people. Construction of the church was funded by the wealthy John D. Rockefeller.

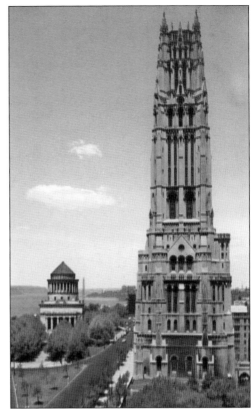

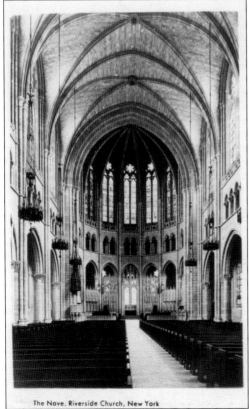

The Nave. Riverside Church, New York

RIVERSIDE CHURCH NAVE. This Franklin Photos postcard from around 1950 shows the soaring arches of the 100-foot-high nave. Construction of the nave was hampered by a fire in December 1928, but it was completed in less than two years, and the first mass was held in October 1930.

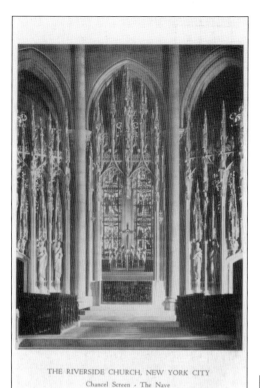

THE RIVERSIDE CHURCH, NEW YORK CITY
Chancel Screen · The Nave

RIVERSIDE CHURCH CHANCEL SCREEN.
The incredibly ornate carvings on the screen
depict a total of 70 different important
historical figures who made a positive impact
on humanity—prophets, teachers, physicians,
humanitarians, missionaries, reformers, and
artists ranging from Louis Pasteur to Socrates
to Abraham Lincoln.

RIVERSIDE CHURCH NARTHEX. The
narthex of this church contains original
Renaissance-era stained-glass windows.
The 16th-century Flemish windows were
removed from an unidentified French
church around the time of the French
Revolution and depict scenes from
Christ's life.

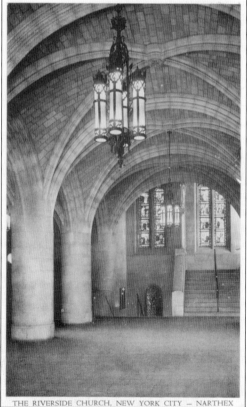

THE RIVERSIDE CHURCH, NEW YORK CITY — NARTHEX

122

RIVERSIDE CHURCH CHRIST CHAPEL. The chapel at Riverside Church is based on an earlier architectural style than the rest of the church. It was modeled after the 11th-century Romanesque nave of the Church of Saint-Nazaire in Carcassonne, France. The intimate chapel is a popular spot in New York for couples to wed. The church is unique in that aside from the main church, the Christ Chapel, and the smaller Meditation Chapel, the church also has four separate spaces for wedding receptions, including the ninth and tenth floors of the tower.

RIVERSIDE CHURCH AERIAL VIEW. The 392-foot-high tower of the church houses the Laura Spelman Rockefeller Memorial Carillon consisting of 72 bells. The largest of the bells is the 20-ton Bourdon (hour bell), the heaviest carillon bell ever cast. The majority of the bells were moved from the Park Avenue Baptist Church, Riverside's predecessor church.

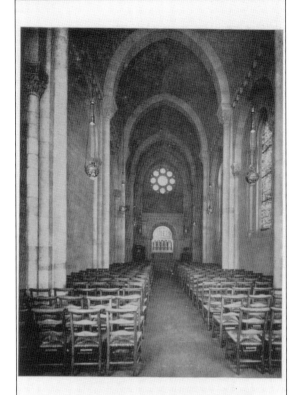

THE RIVERSIDE CHURCH, NEW YORK CITY
The Chapel

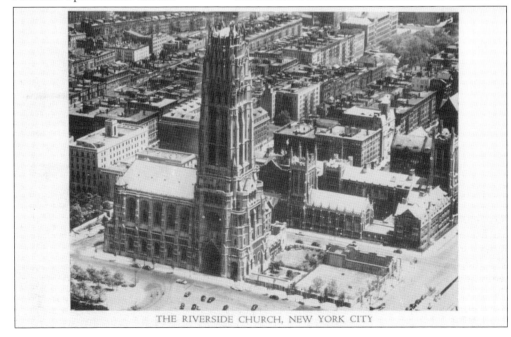

THE RIVERSIDE CHURCH, NEW YORK CITY

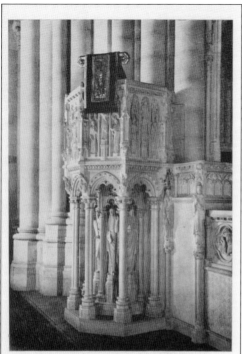

THE RIVERSIDE CHURCH IN THE CITY OF NEW YORK
Pulpit · The Nave

RIVERSIDE CHURCH PULPIT. The Riverside pulpit has had several speakers of note over the years, including Dr. Martin Luther King, who addressed the congregation on April 4, 1967, in a now-famous anti-Vietnam speech called "A Time to Break Silence." Nelson Mandela has also spoken from this pulpit.

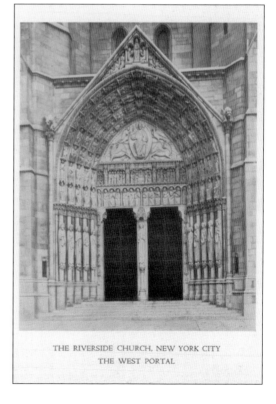

THE RIVERSIDE CHURCH, NEW YORK CITY
THE WEST PORTAL

RIVERSIDE CHURCH WEST PORTAL. The West Portal, facing Riverside Drive, is the main entrance to the church. It features five sculpted stone arches that depict angels as well as 42 figures of scientists, philosophers, and religious leaders. The portal design was based on the doors at the Notre-Dame de Chartres Cathedral, which was the inspiration for much of Riverside Church's design.

SWEDISH LUTHERAN CHURCH. Originally used as the Builders' League of New York clubhouse, the structure depicted in this postcard (74 West 126th Street) was briefly the Swedish Lutheran Church. Starting in 1910, the building hosted the Lenox Avenue Union Church-Disciples of Christ, which had moved from 37 West 119th Street. The building hosted the Transfiguration Lutheran Church starting in 1923. The gabled top of this church was long ago squared off, creating a less dramatic visual effect.

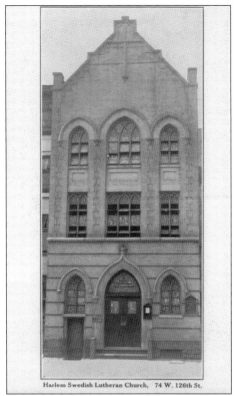

Harlem Swedish Lutheran Church, 74 W. 126th St.

LENOX AVENUE UNION CHURCH. This advertisement for the church is printed on the back of a picturesque colored rural scene in Nova Scotia. The church was founded in 1889 and its first building was located at 37 West 119th Street before it moved to 74 West 126th Street in 1910, not long before this postcard was mailed. The church was no longer in existence by 1928.

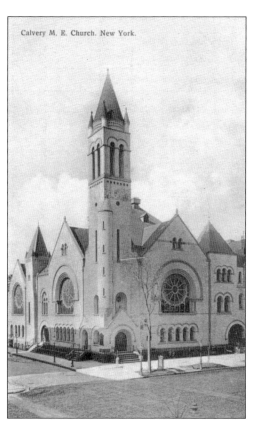

Calvery M. E. Church, New York.

CALVARY METHODIST EPISCOPAL CHURCH. This striking stone and brick Romanesque Revival building (seen on a card postmarked in 1909) was constructed in 1887 at 211 West 129th Street in Harlem and expanded just three years later. The church moved to 1885 University Avenue in the Bronx in 1923. This building then became home to the Salem Methodist Episcopal Church, which had previously been on 133rd Street. The current address of the building is 2190 Adam Clayton Powell Jr. Boulevard.

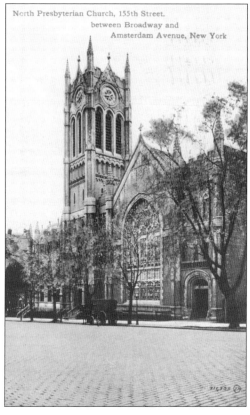

North Presbyterian Church, 155th Street, between Broadway and Amsterdam Avenue, New York.

NORTH PRESBYTERIAN CHURCH. Founded in 1847, the church was originally located on Ninth Avenue at Thirty-First Street. It was demolished in about 1903 to make way for Pennsylvania Station and its associated rail yards. The church then moved several miles uptown to its current location at 525 West 155th Street, between Broadway and Amsterdam Avenue. It was once the second-largest Presbyterian congregation in New York City. Designed by Bannister and Schell and completed in 1904, the current building also offers a home to Mawuhle Presbyterian Church, a mostly Ghanaian congregation. This church is across the street from the Church of the Intercession.

CHAPEL OF THE INTERCESSION. This impressive edifice stands at 550 West 155th Street. Originally an independent parish, the Church of the Intercession experienced financial difficulties around the turn of the 20th century and made a deal to become part of the Trinity Church parish. Between 1906 and 1976 (when it became independent again), it was known as the Chapel of the Intercession. The building, designed by Bertram Grosvenor Goodhue and completed in 1915, became a New York City Landmark in 1966. The inauguration of David Dinkins (a parishioner) as mayor of New York City was celebrated here. The church is located within Trinity's uptown cemetery property. Buried there is Clement Clark Moore, the author of the famous Christmas poem "A Visit from St. Nicholas."

THE CLOISTERS. Located in Fort Tryon Park near the northern tip of Manhattan, the Cloisters is a branch of the Metropolitan Museum of Art. The complex, which houses 2,000 artworks and architectural treasures from medieval Europe, is housed in a complex created using pieces of five different French abbeys. The Cloisters, made possible by donations from John D. Rockefeller, opened to the public in 1938. In 1958, the 12th-century apse from a Spanish church was added to the museum.

DISCOVER THOUSANDS OF LOCAL HISTORY BOOKS FEATURING MILLIONS OF VINTAGE IMAGES

Arcadia Publishing, the leading local history publisher in the United States, is committed to making history accessible and meaningful through publishing books that celebrate and preserve the heritage of America's people and places.

Find more books like this at
www.arcadiapublishing.com

Search for your hometown history, your old stomping grounds, and even your favorite sports team.